ORPHAN BLACK

THE OFFICIAL COLORING BOOK

INSIGHT EDITIONS

San Rafael, California

Join Sarah, Cosima, Alison, Helena, and all the members of Clone Club as they fight to unravel the mysteries at the heart of the thrilling hit show *Orphan Black*. Exciting moments, distinctive outfits, and intricate patterns inspired by the show are yours to design and color.

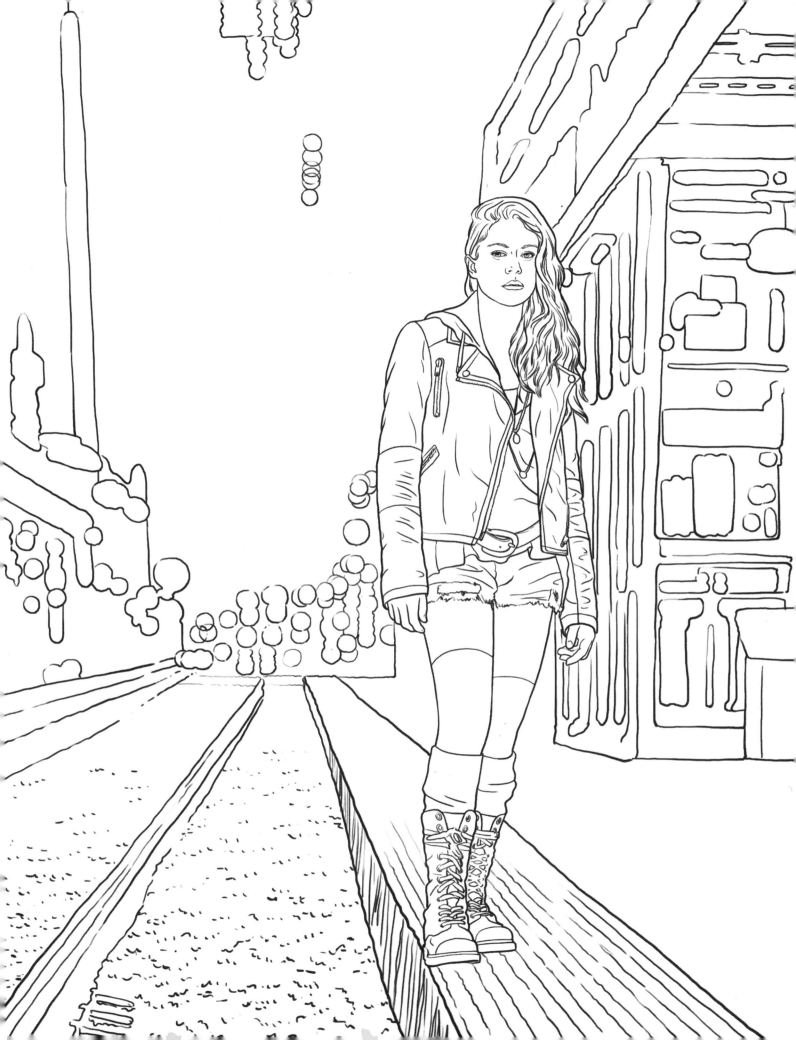

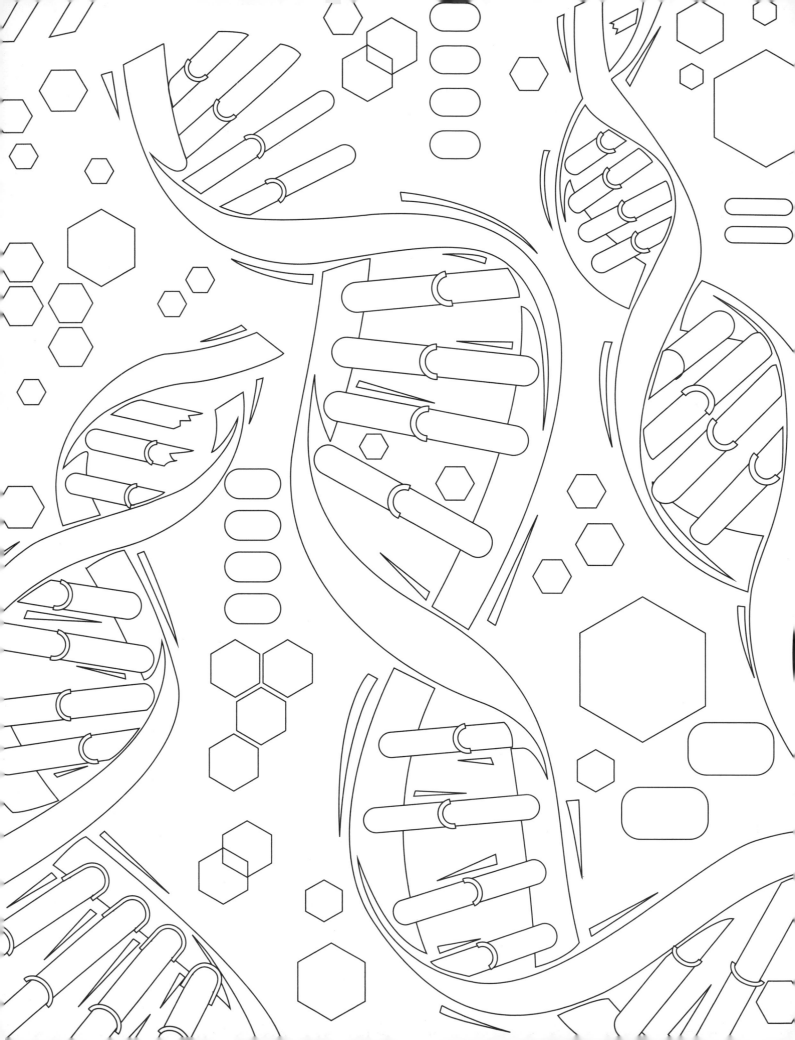

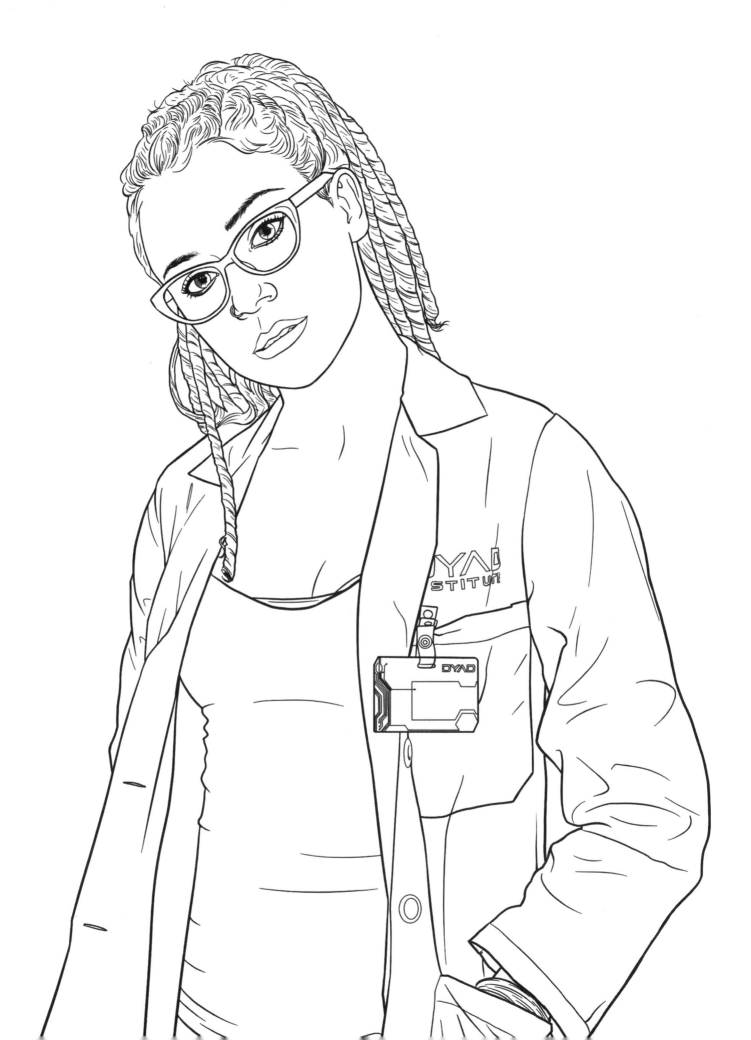

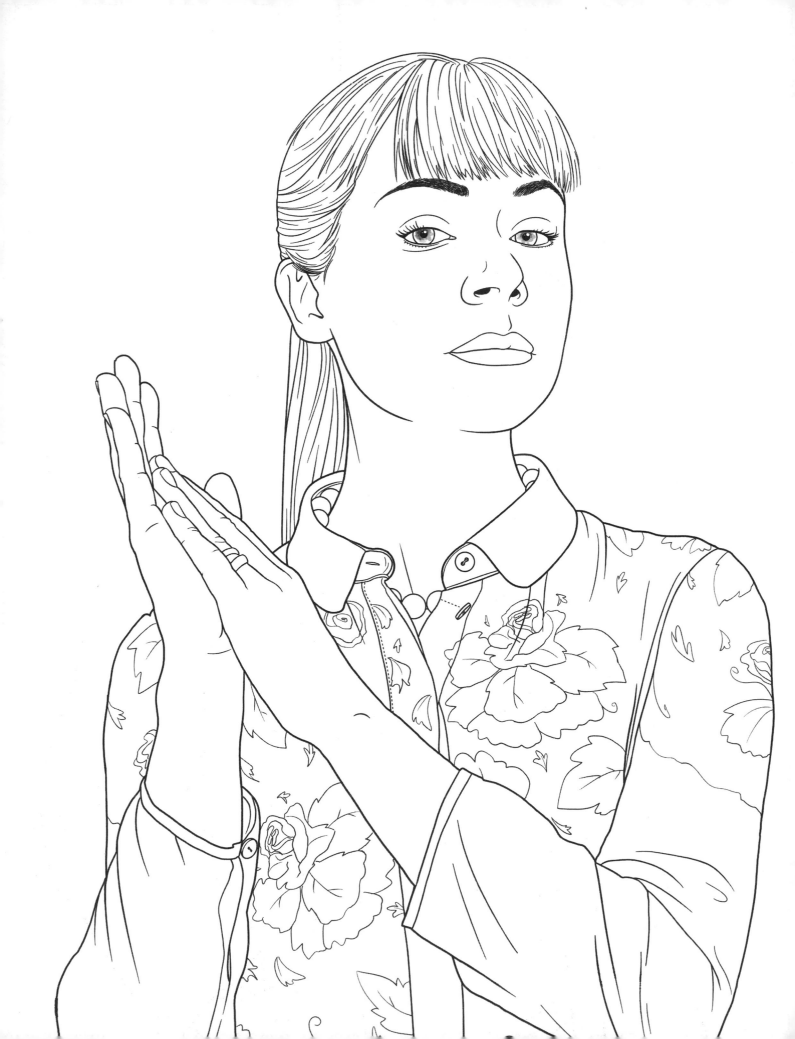

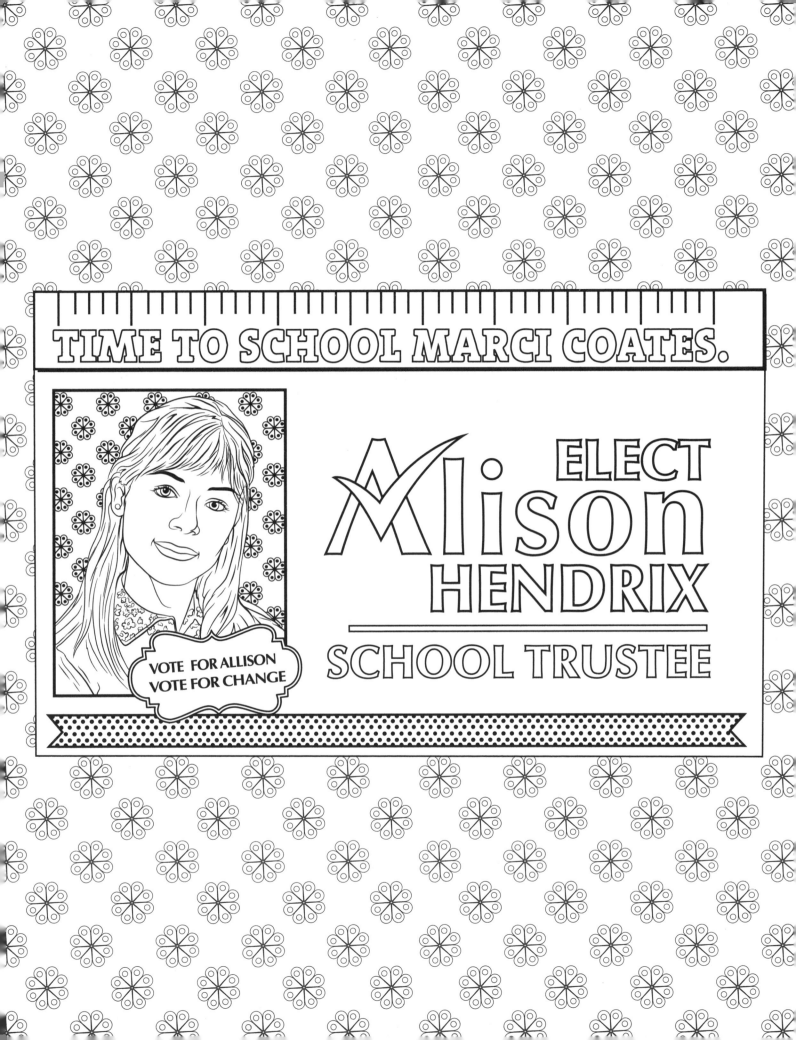

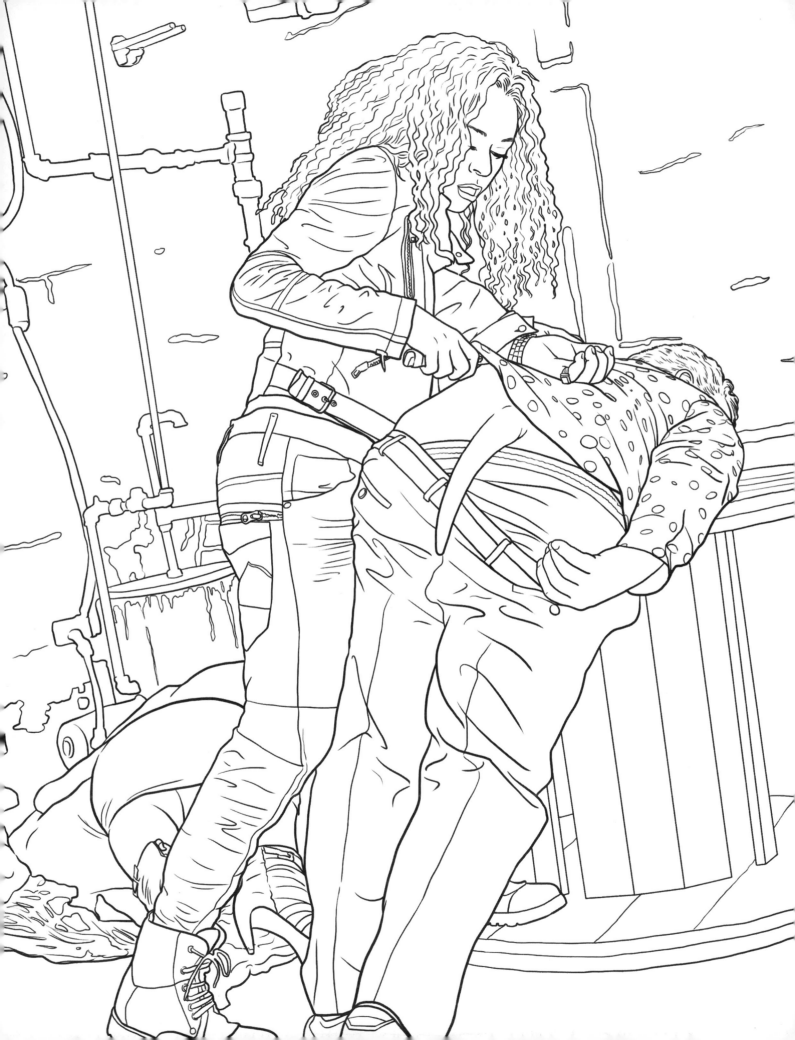

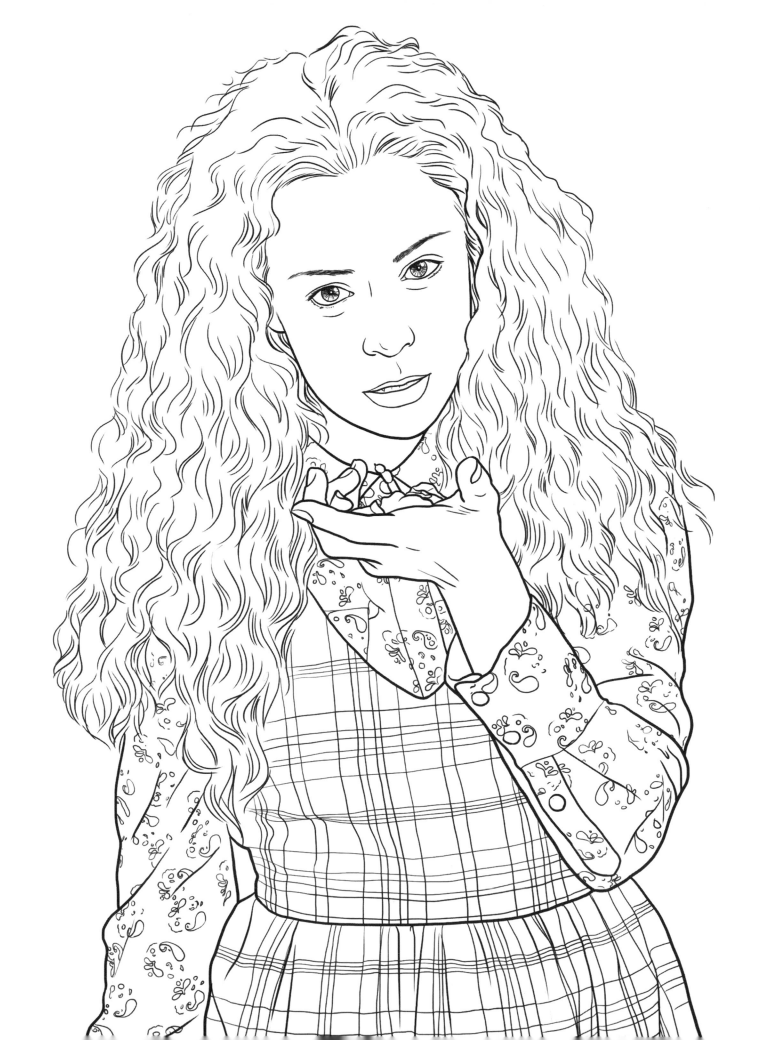

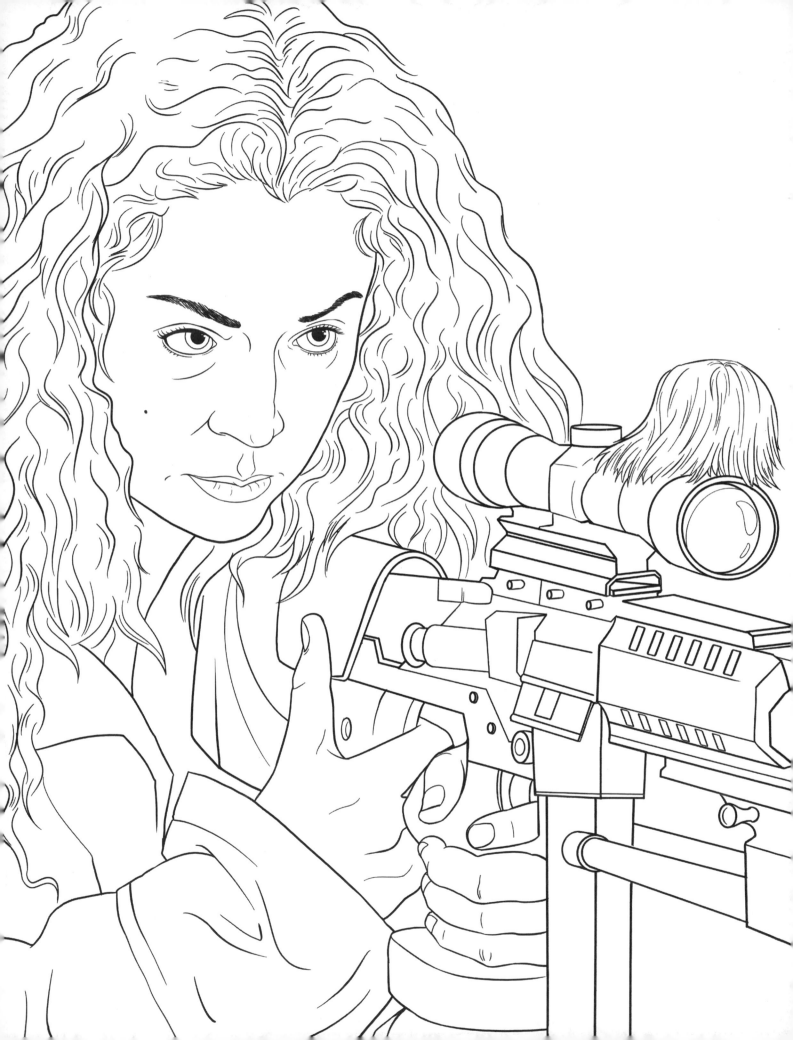

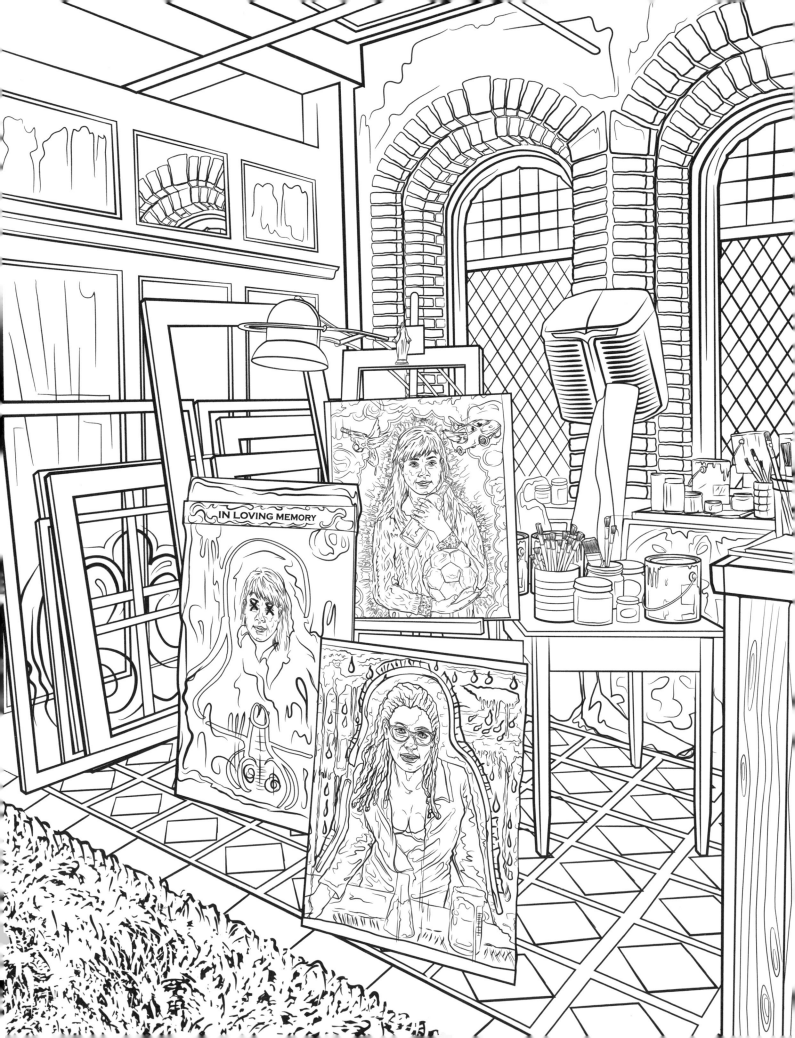

IN LOVING MEMORY

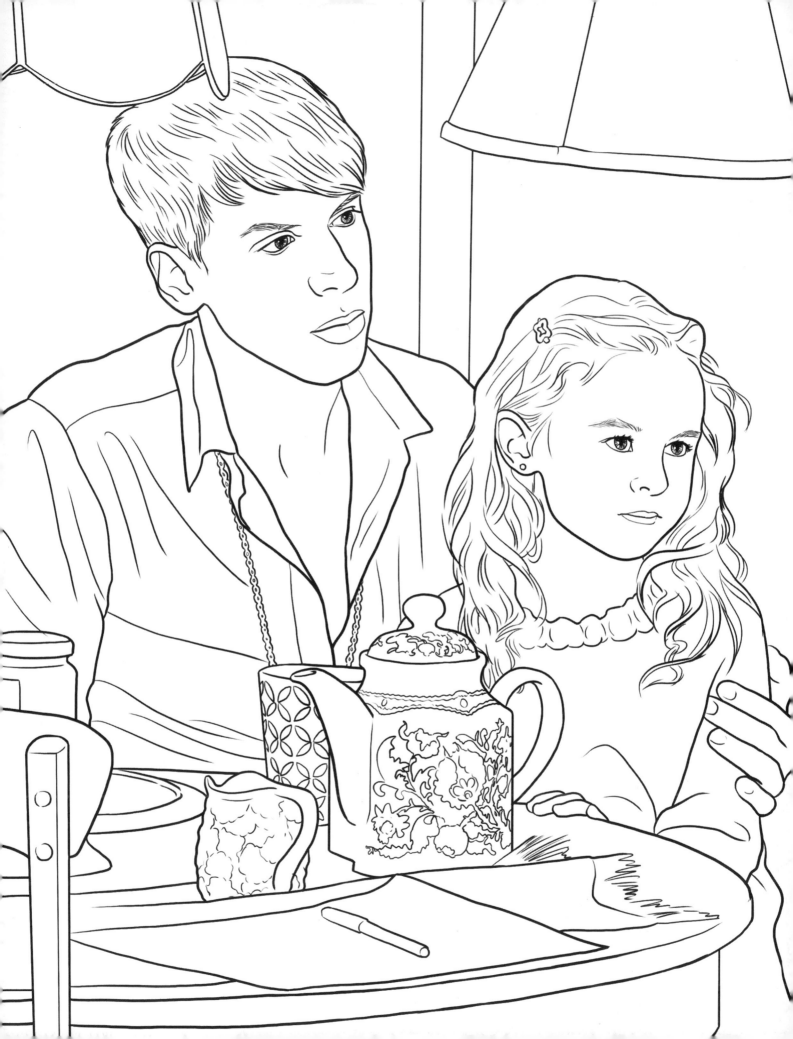

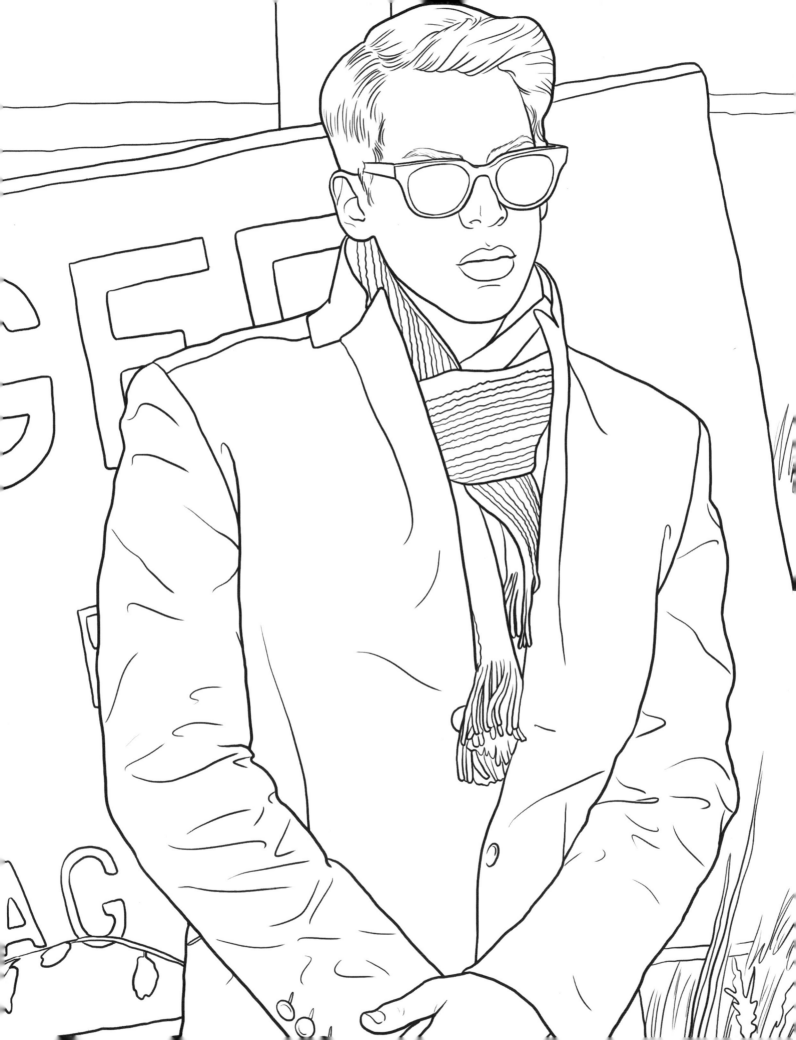

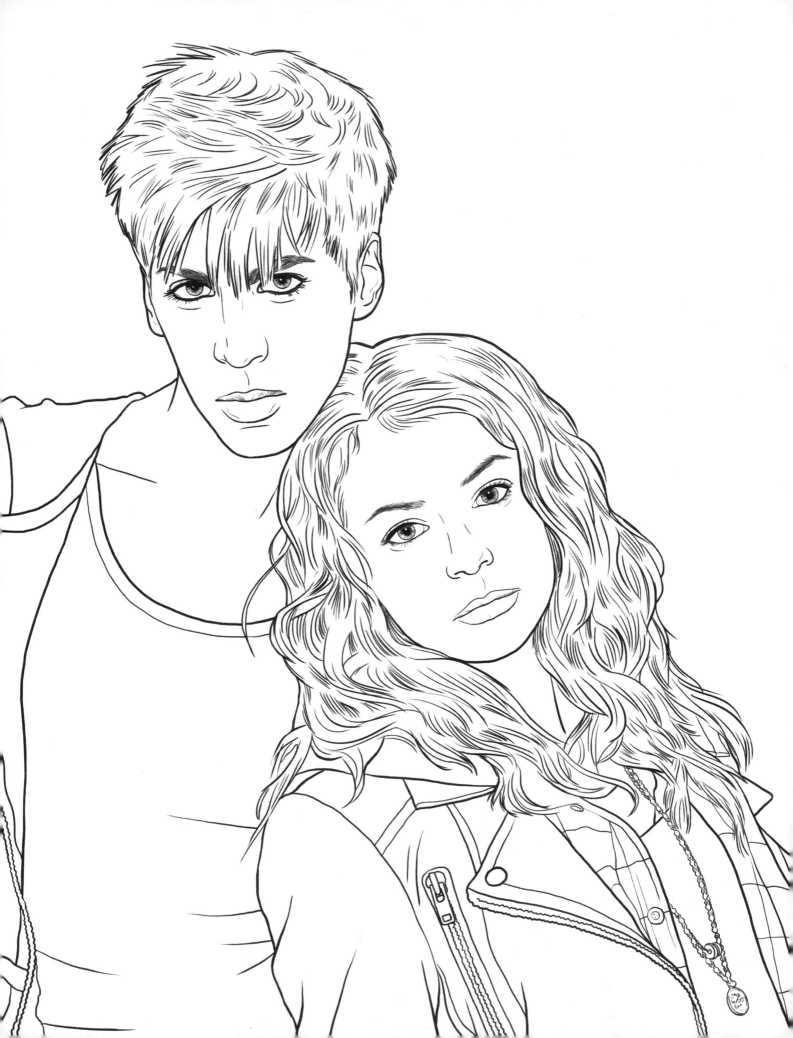

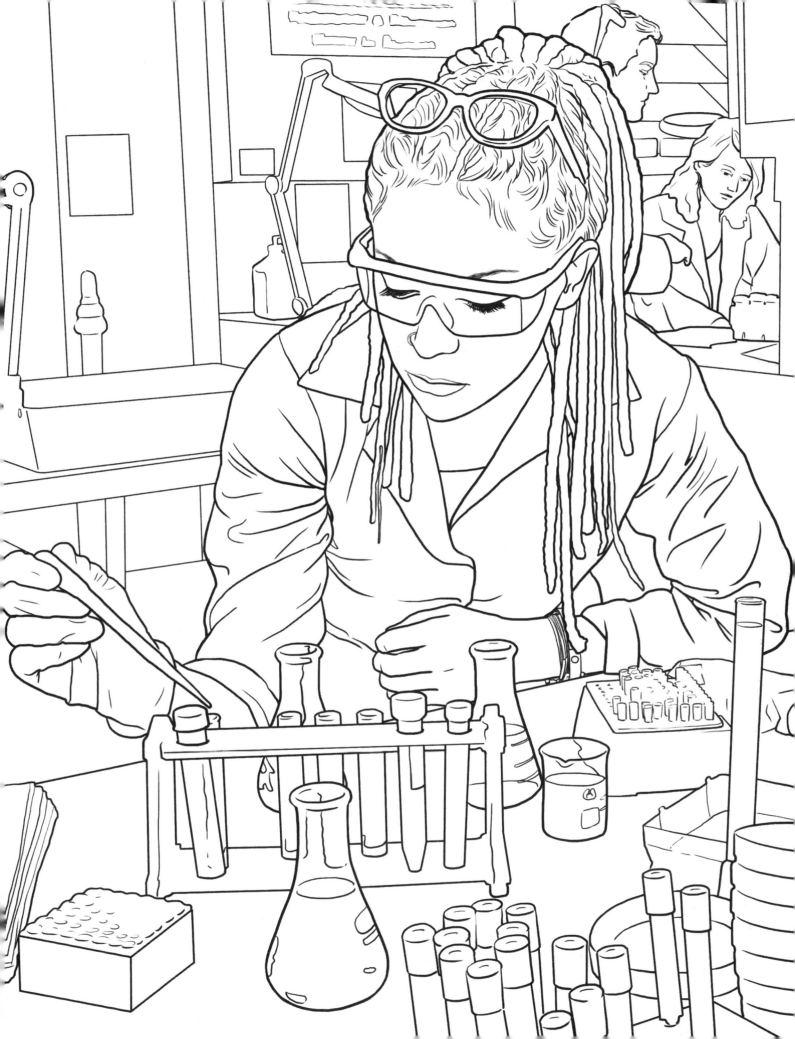

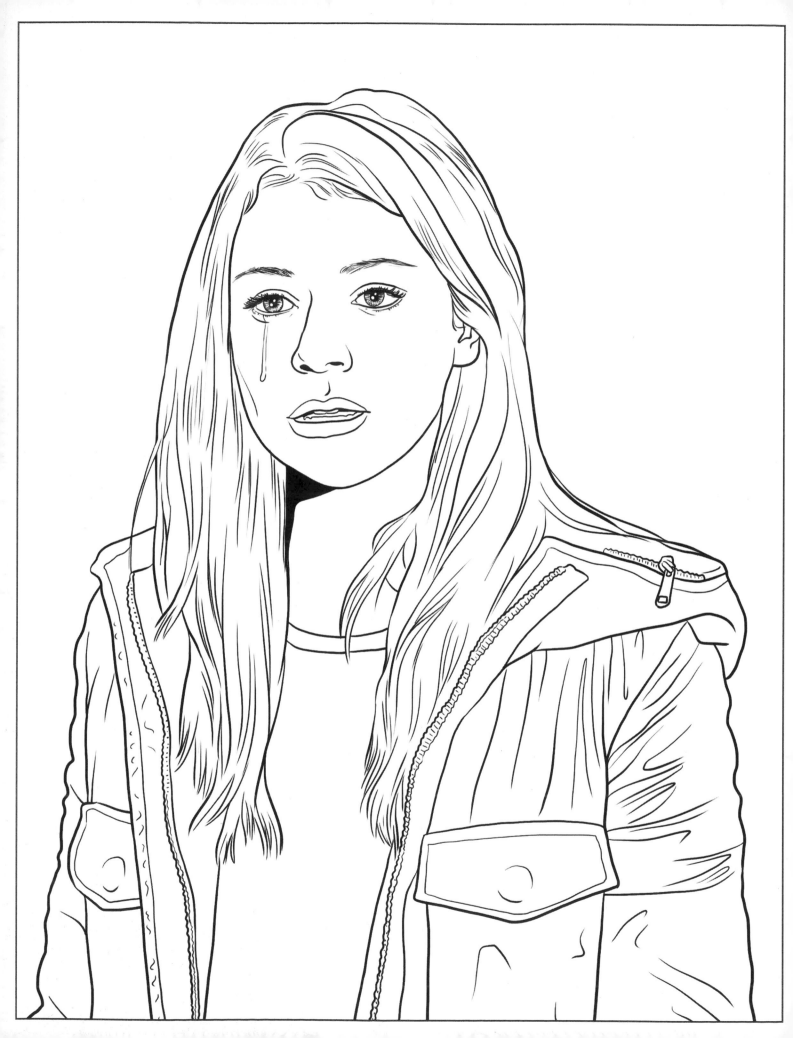

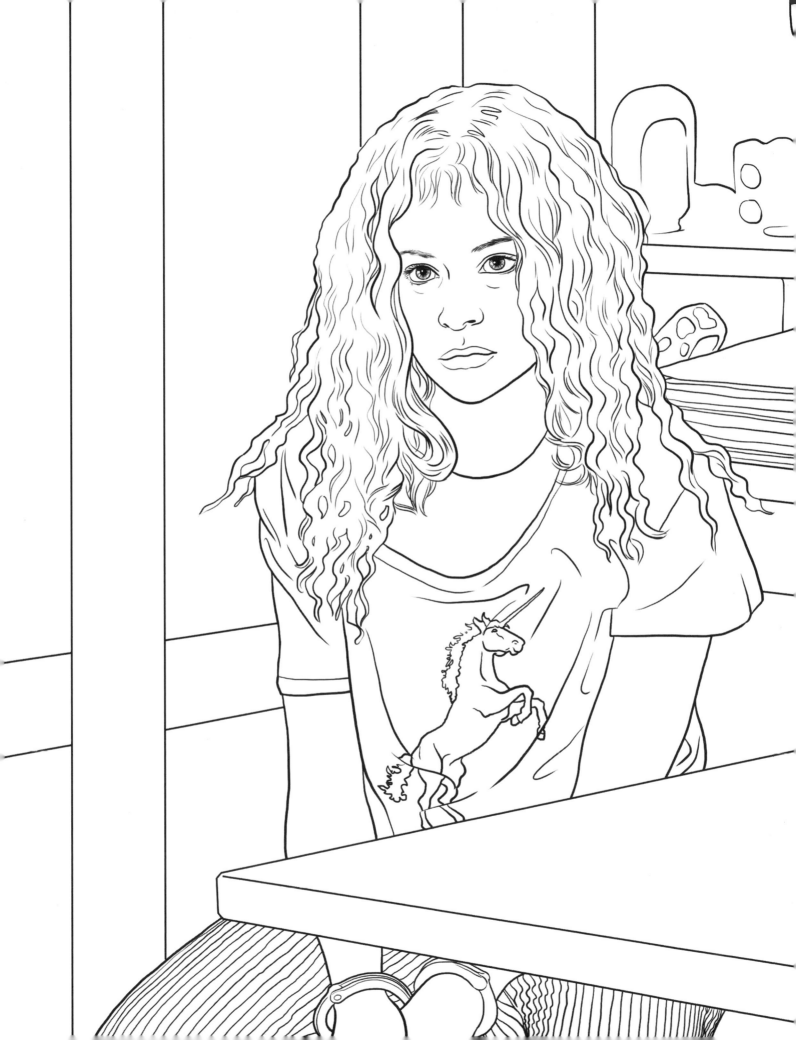

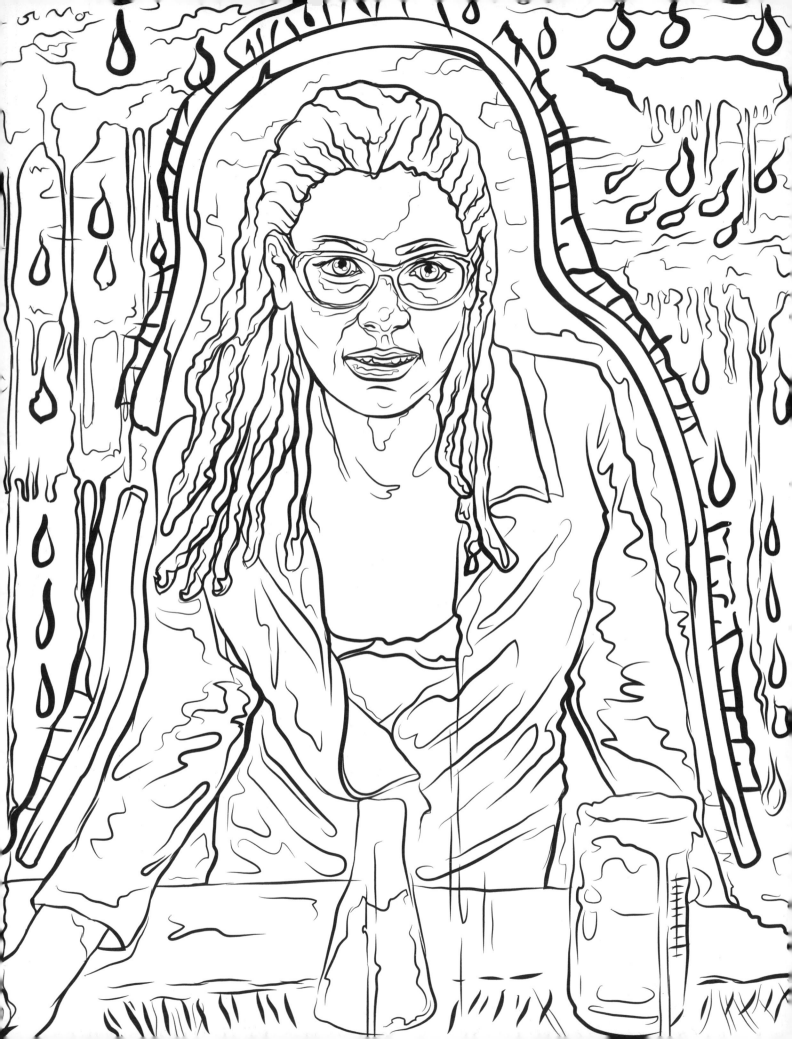

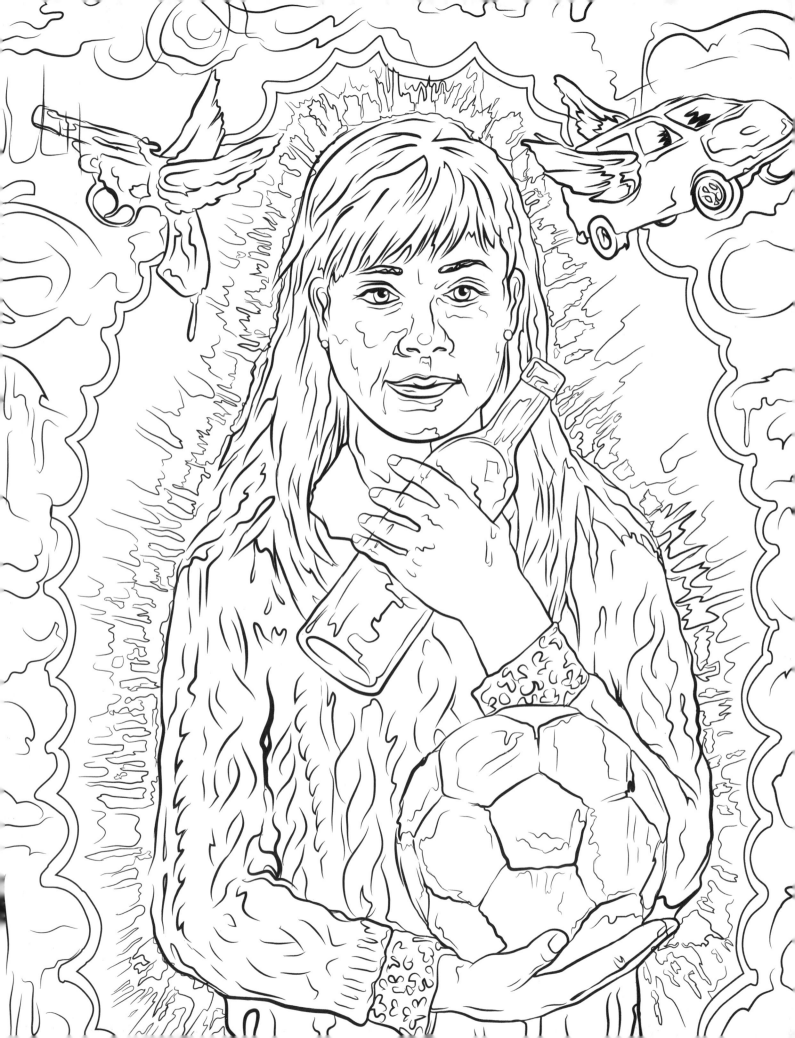

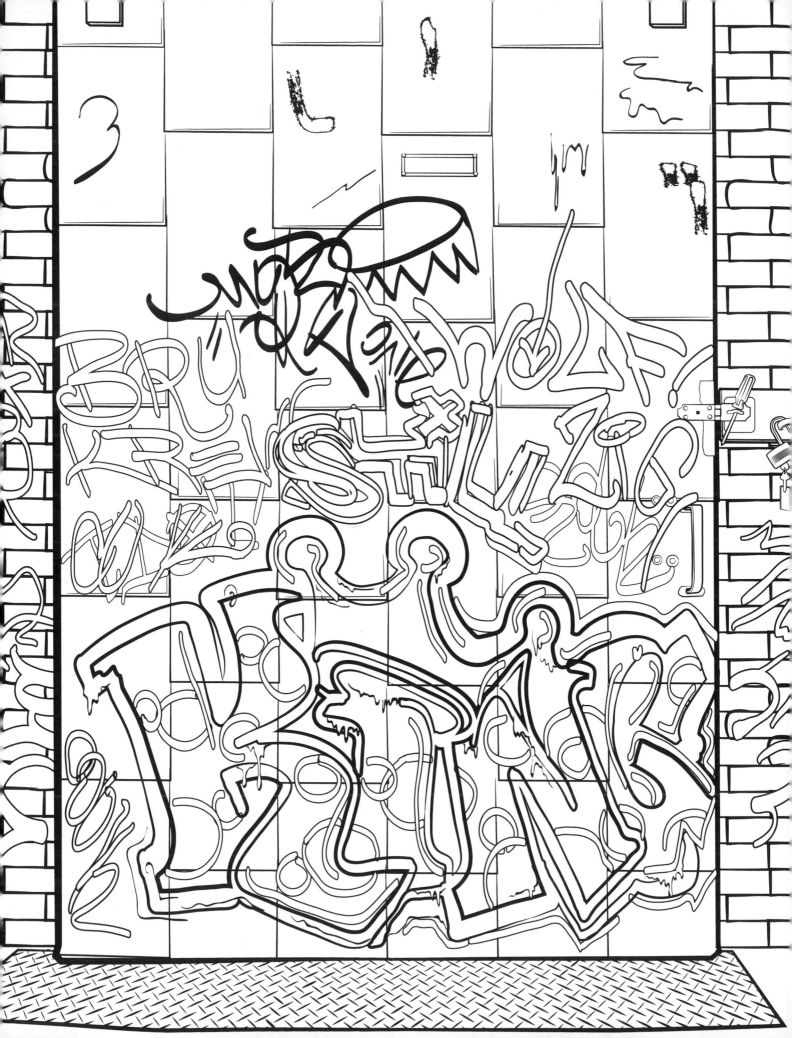

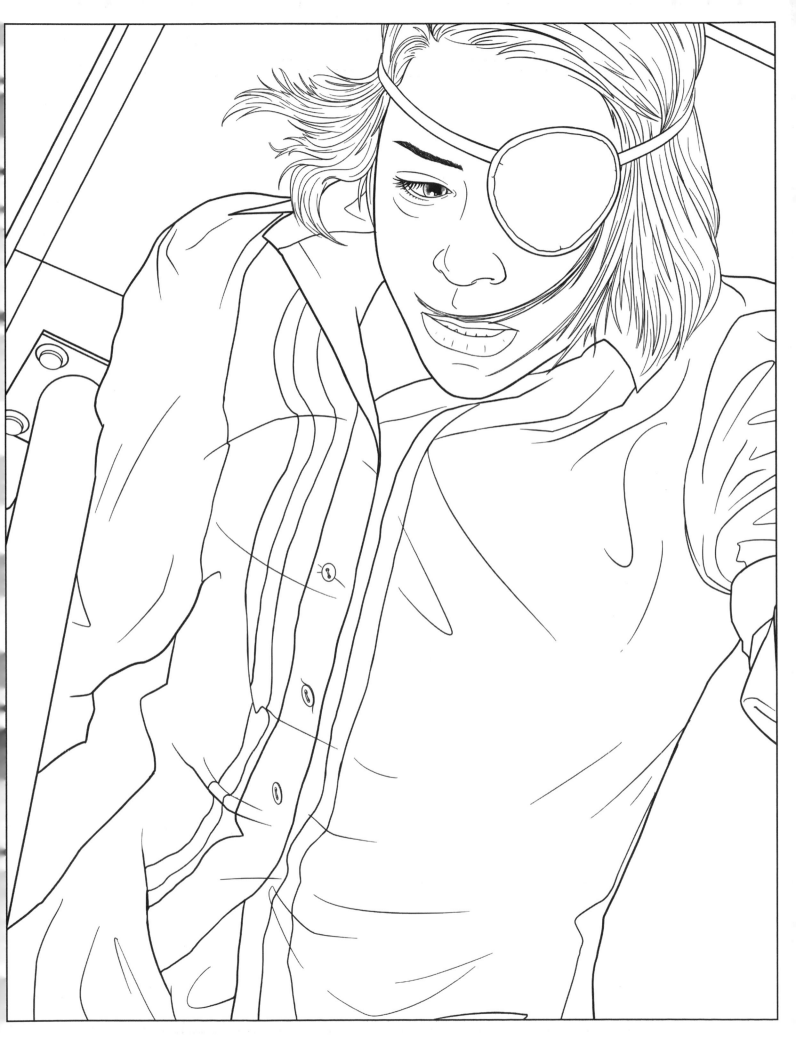

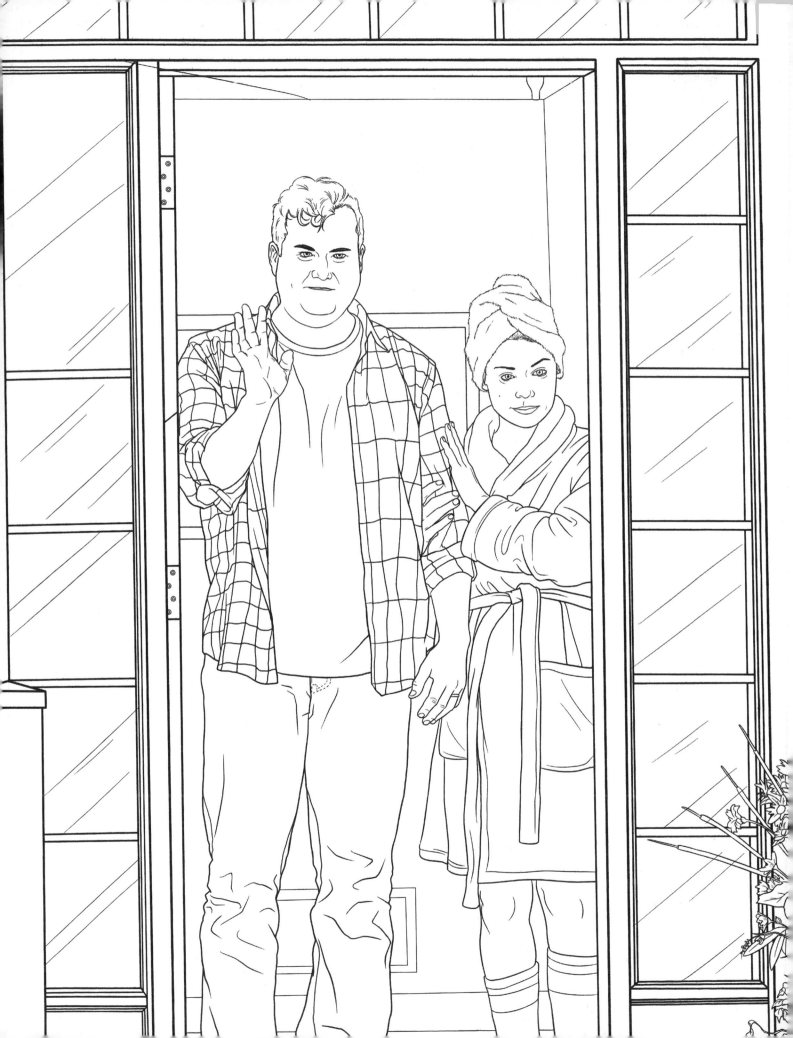

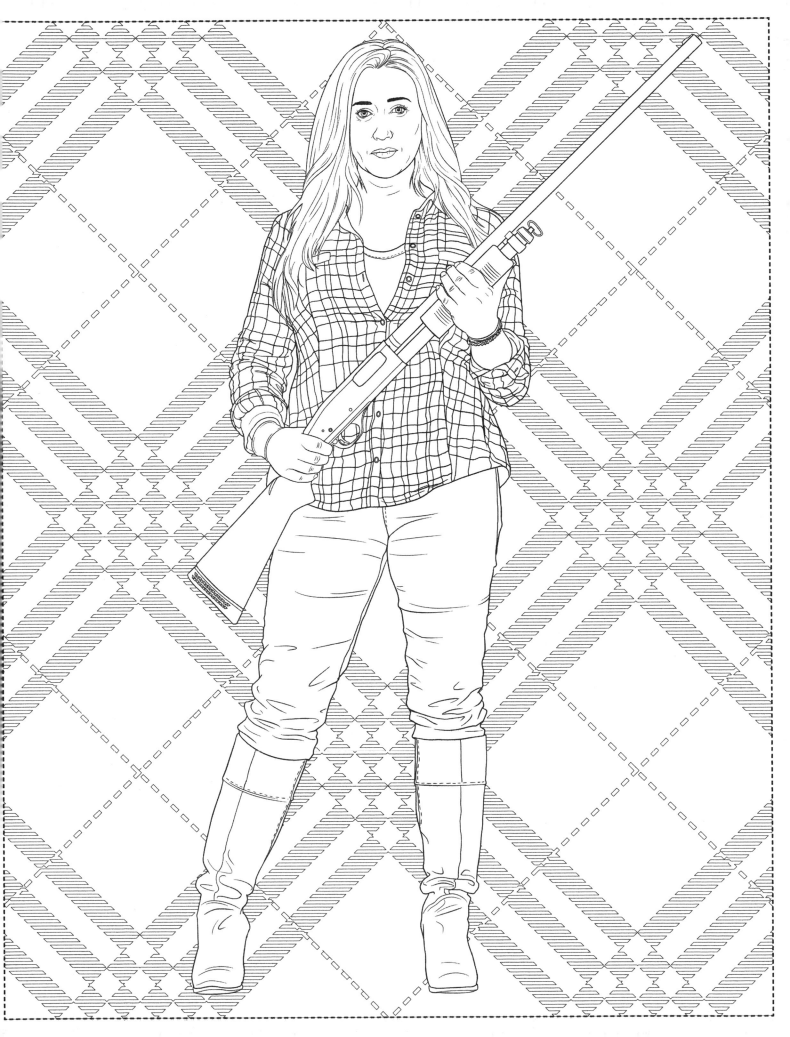

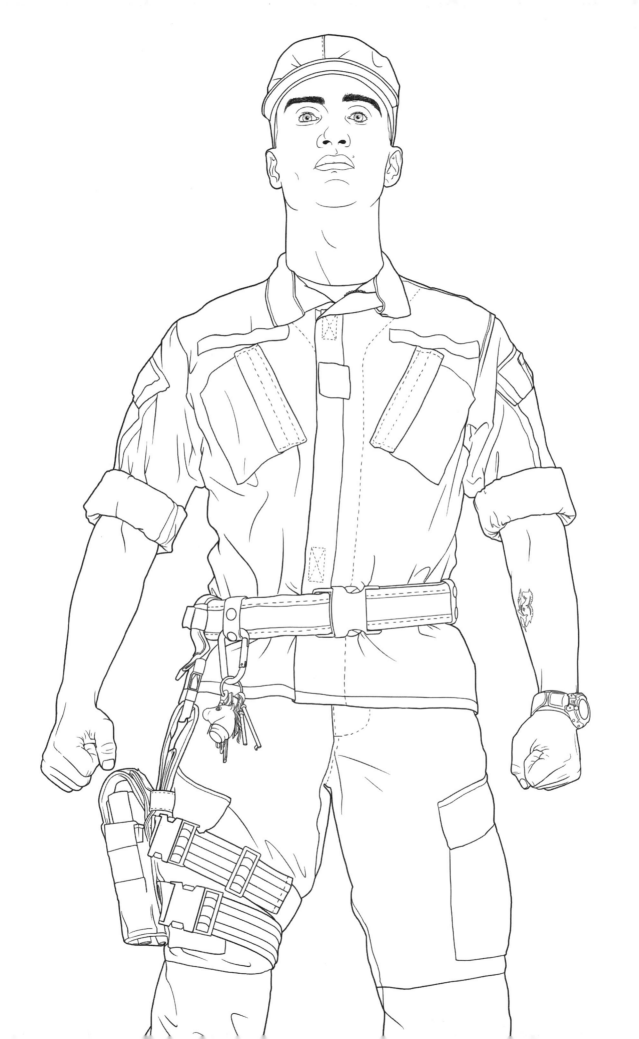

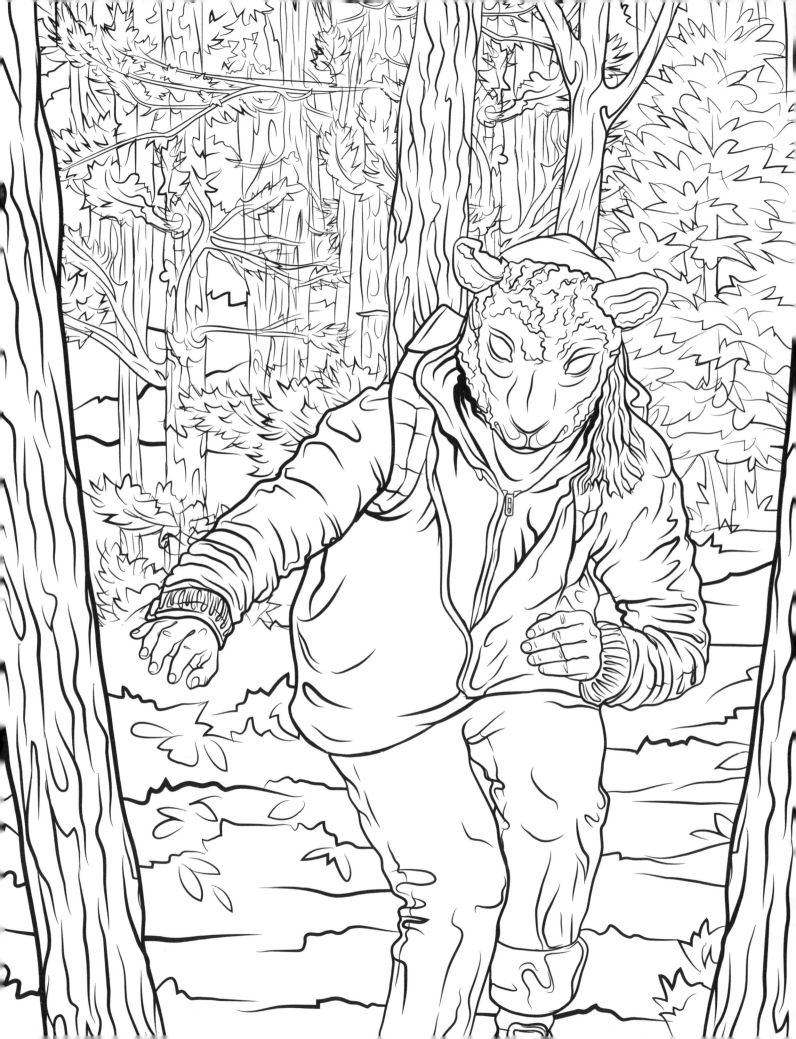

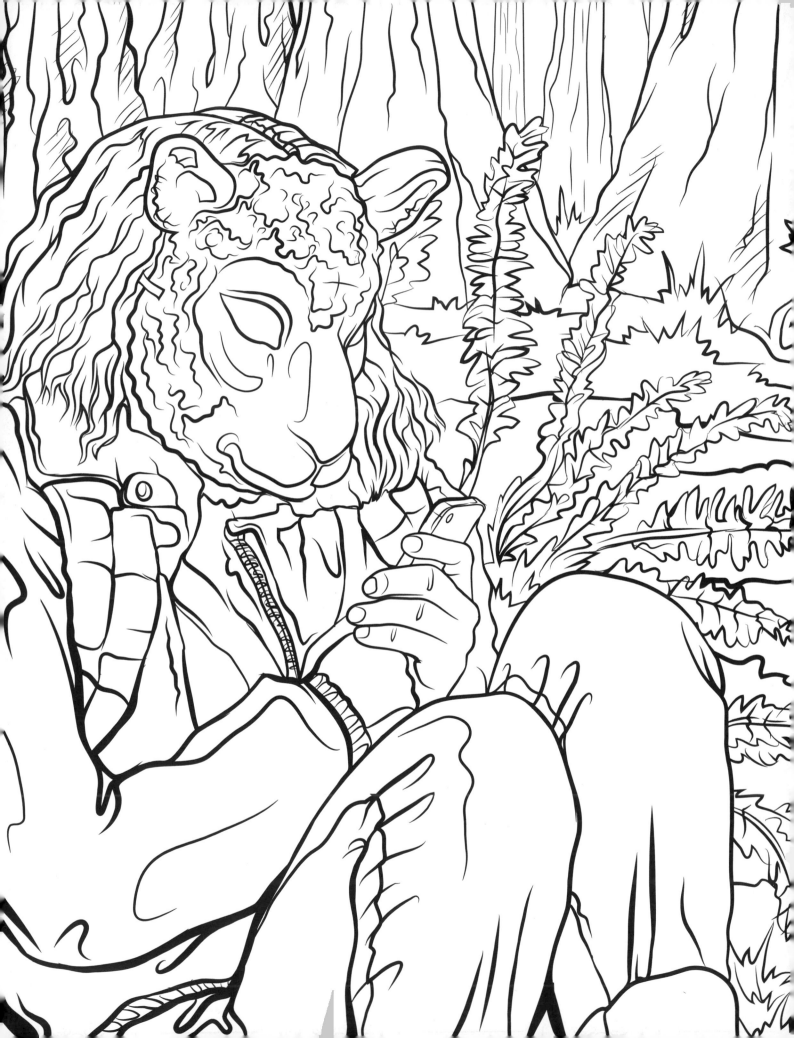

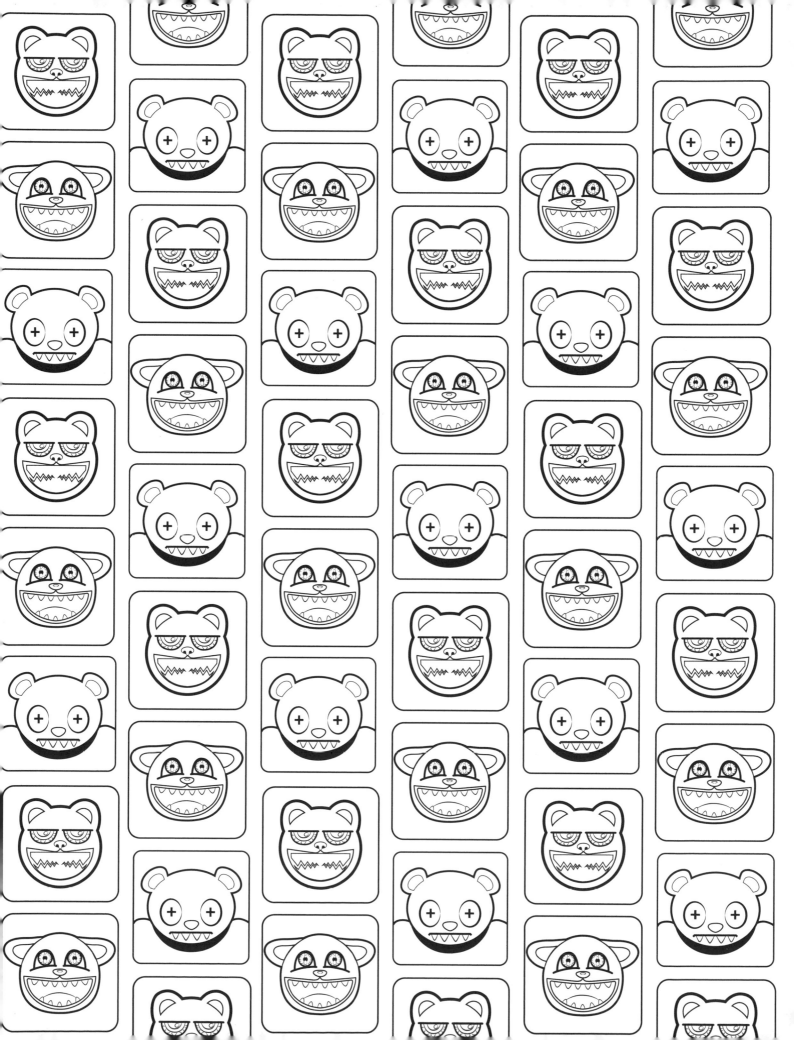

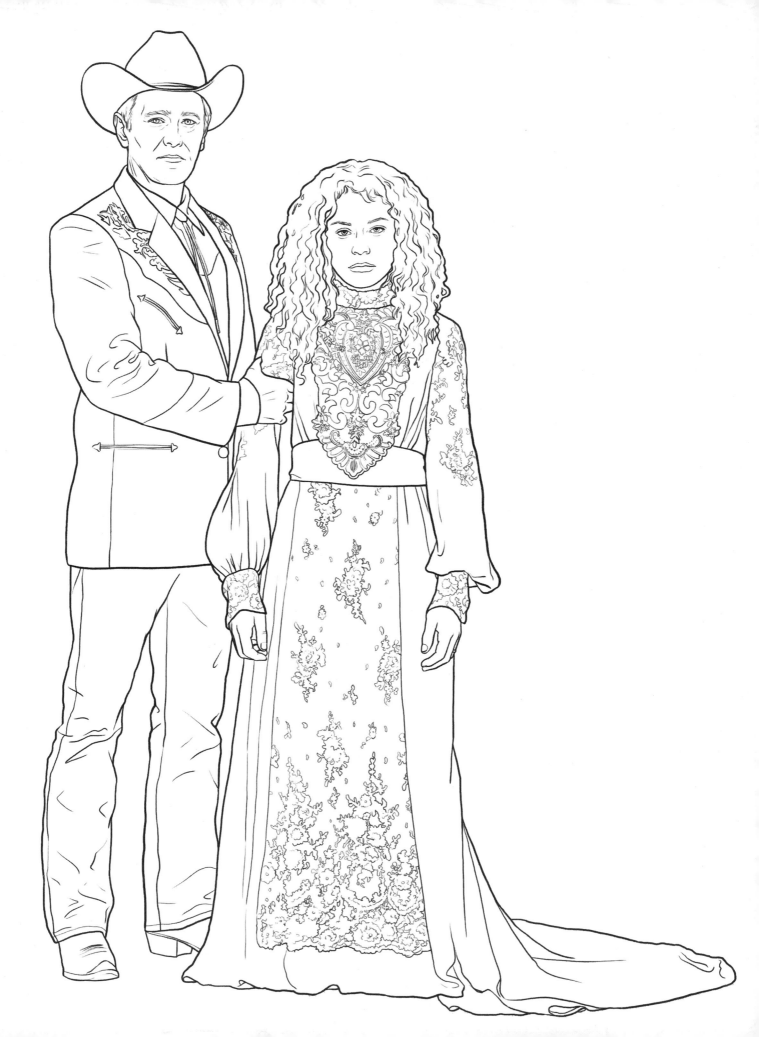

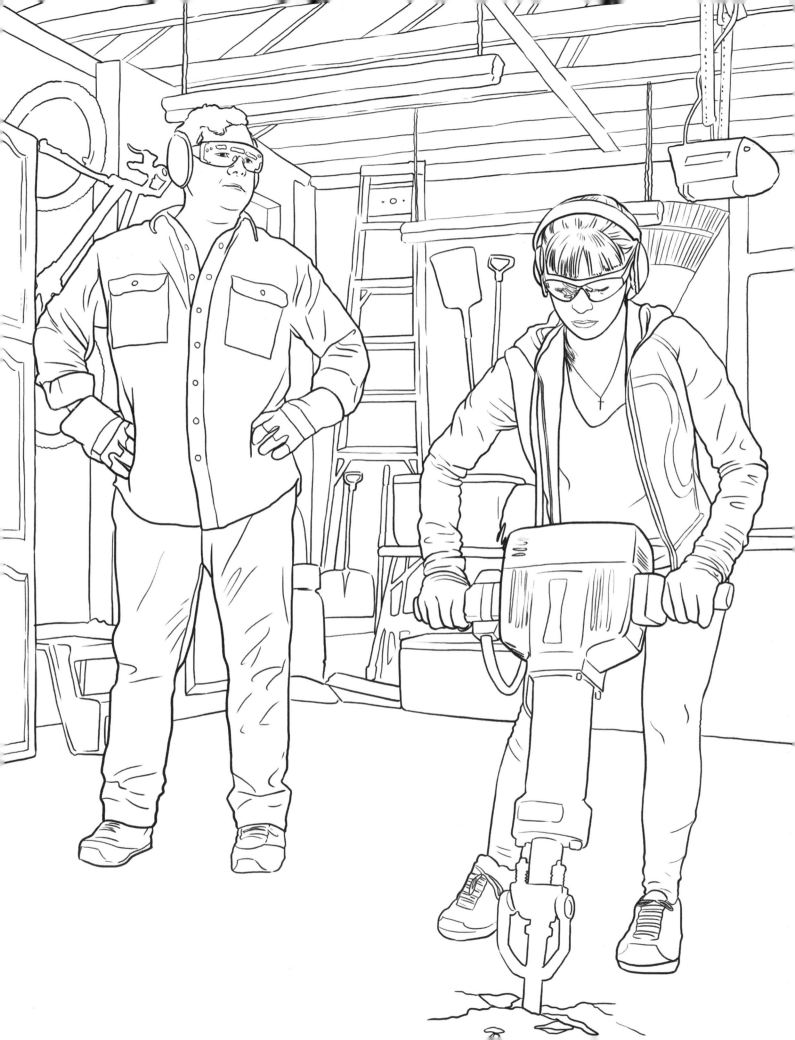

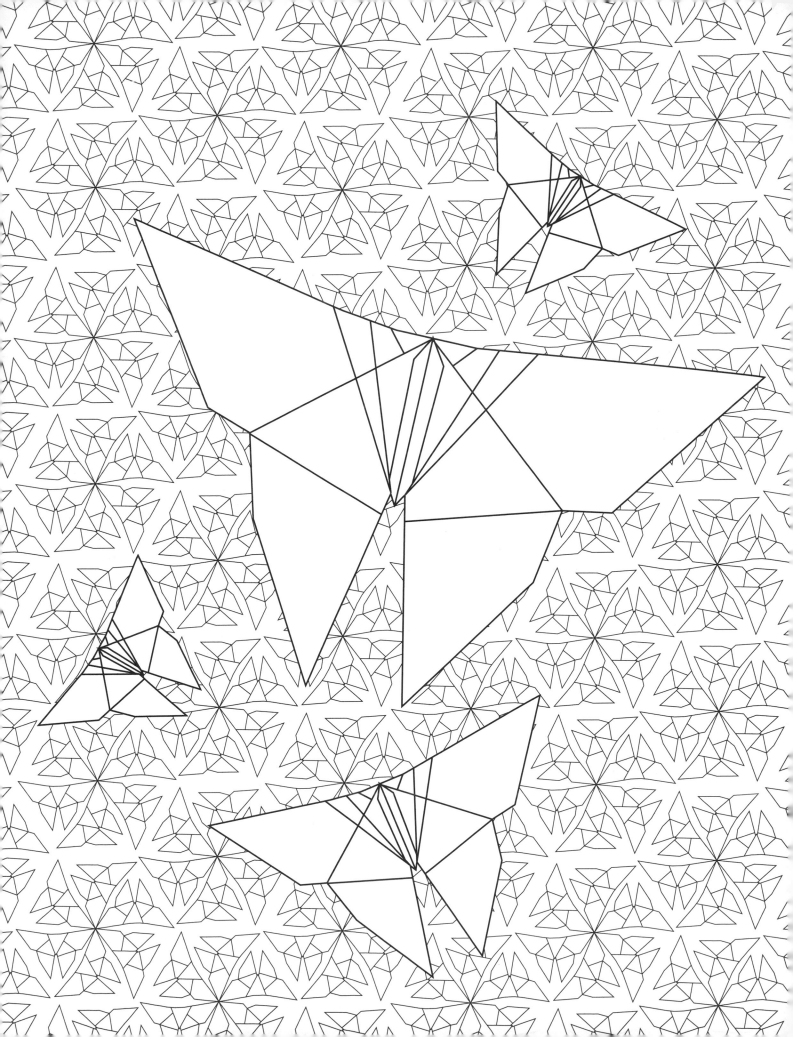

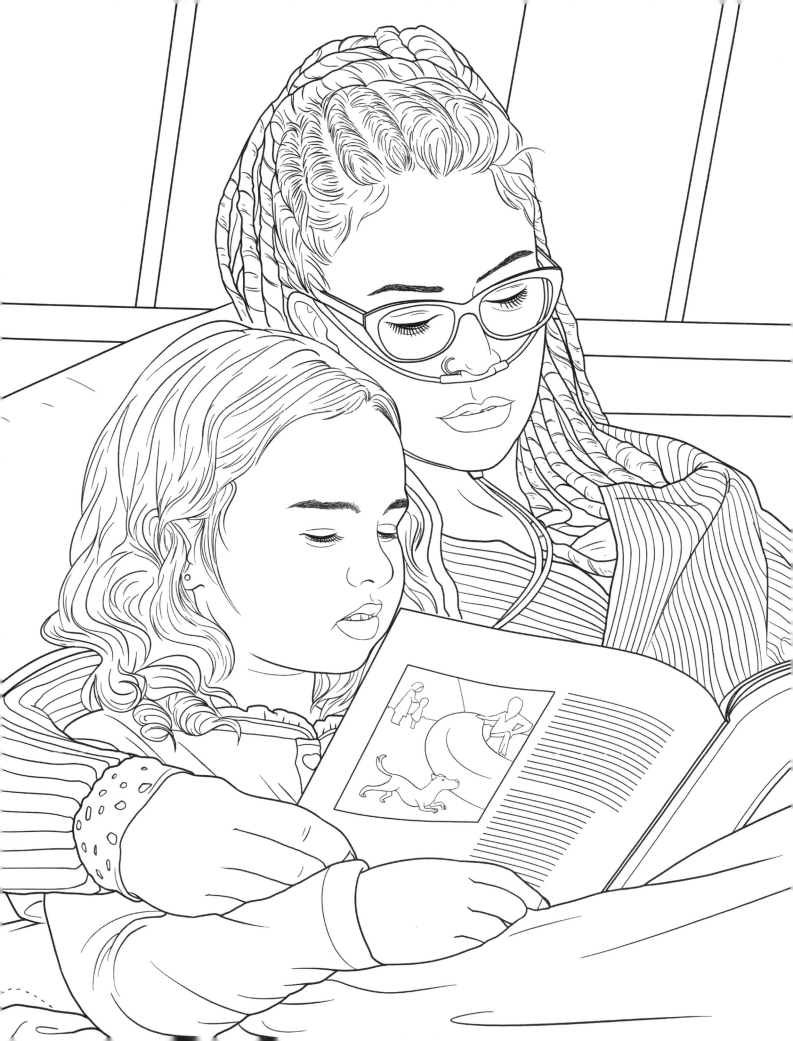

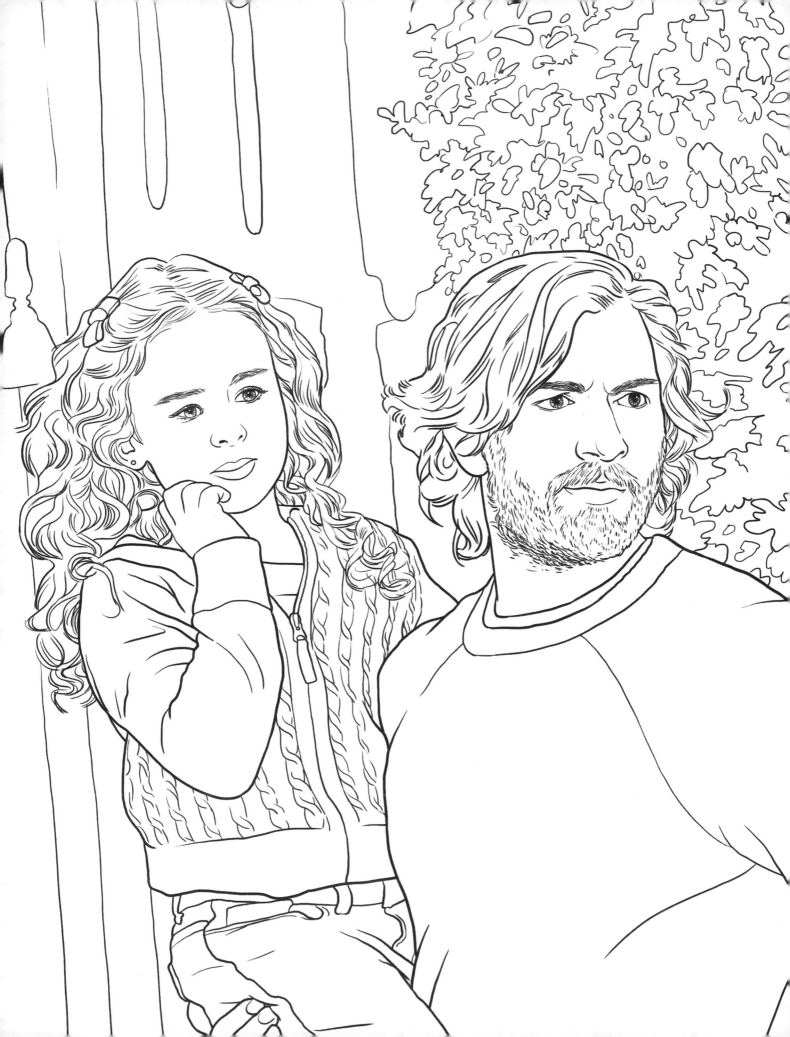

THE INHERITANCE OF ACQUIRED CHARACTERISTICS

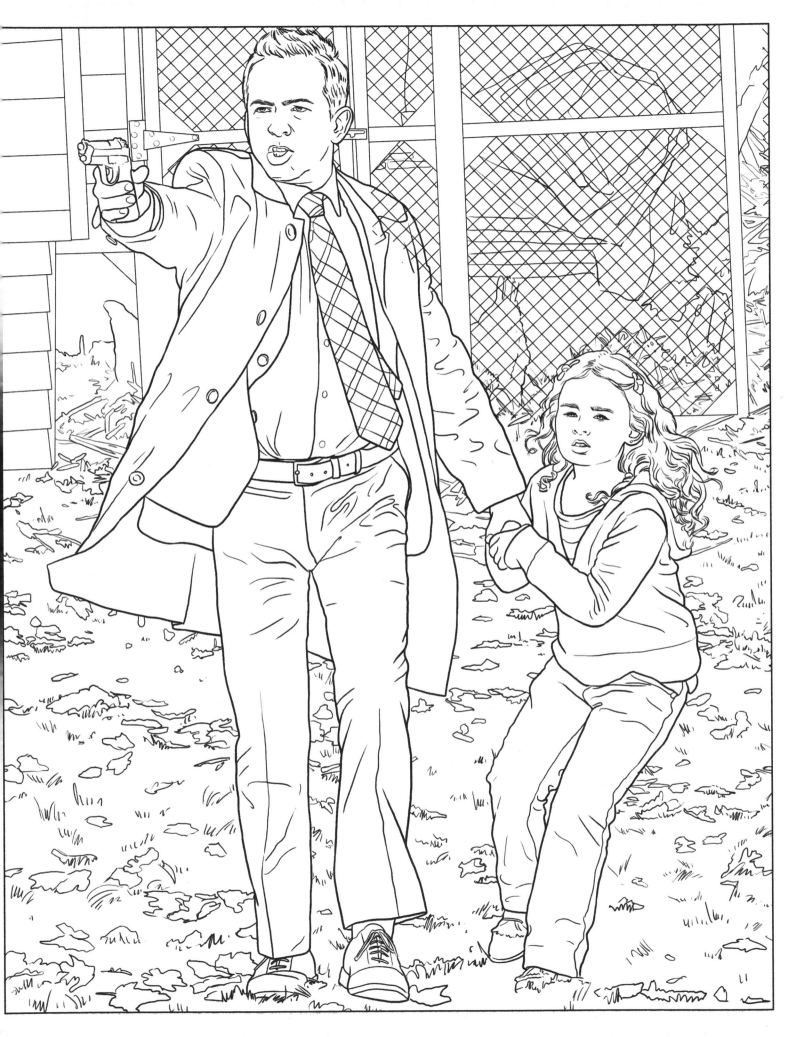

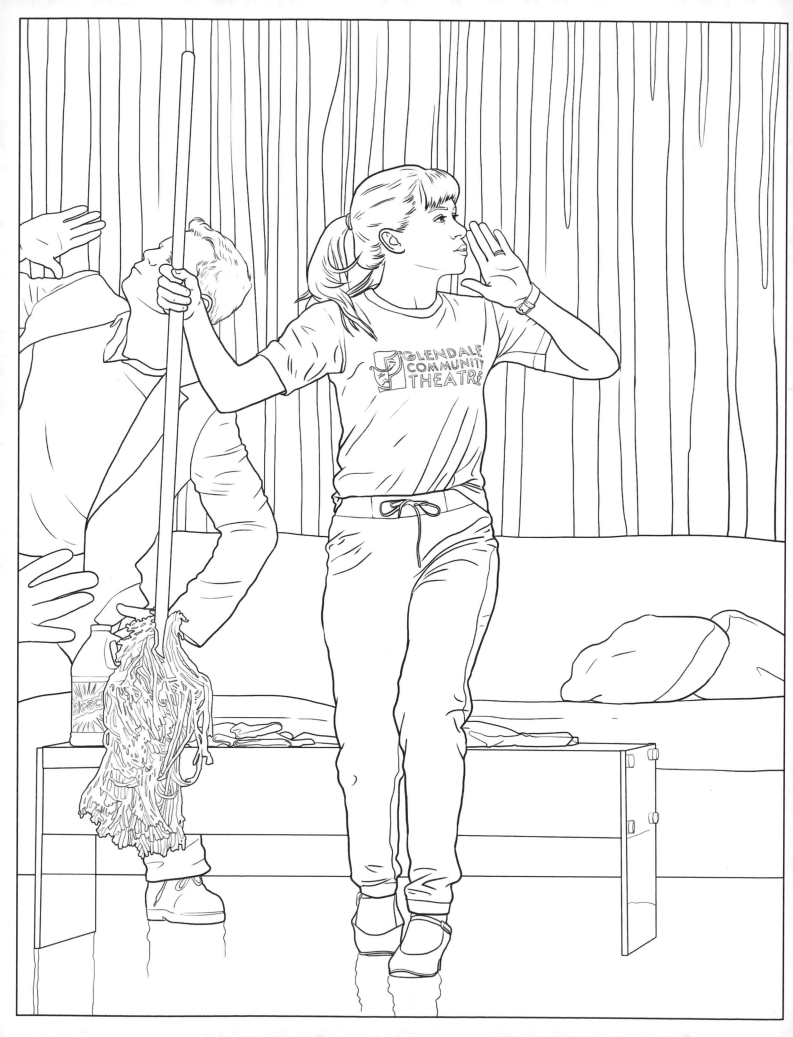

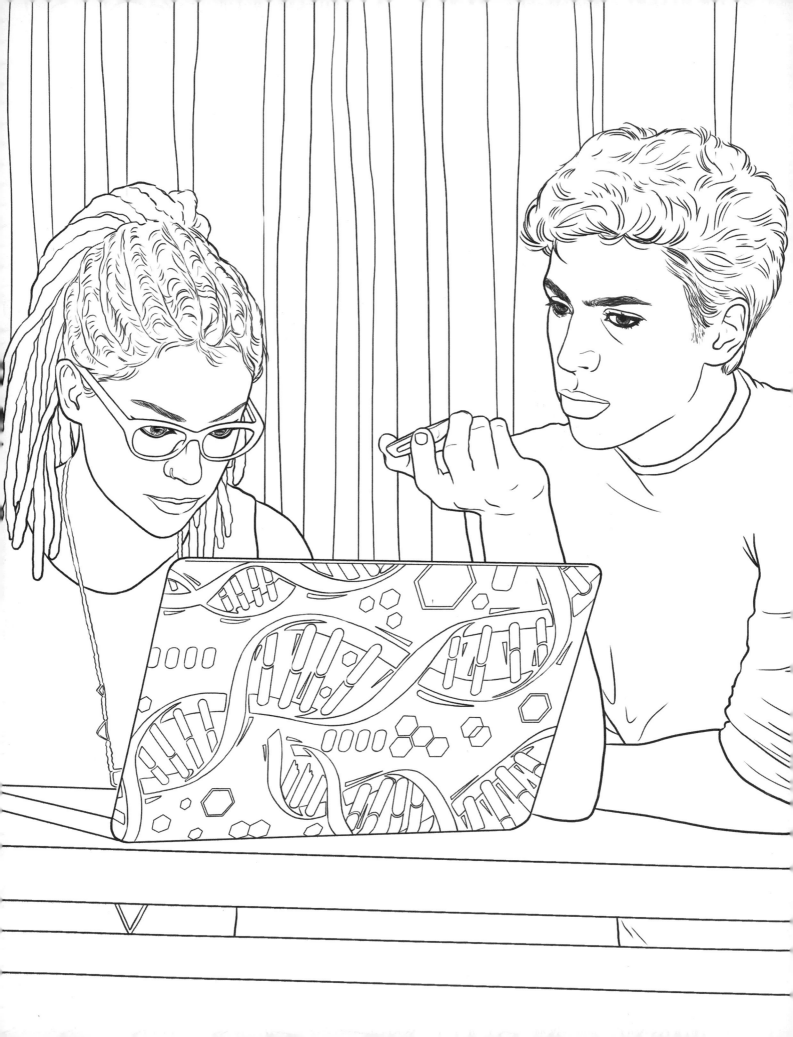

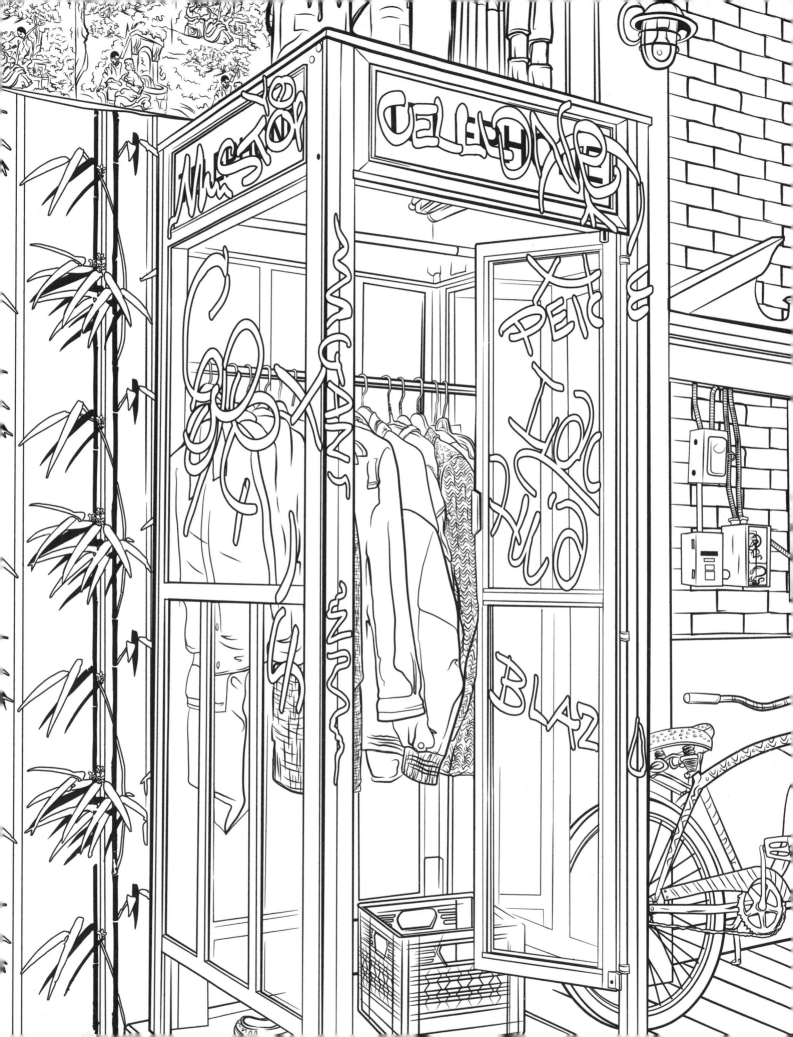

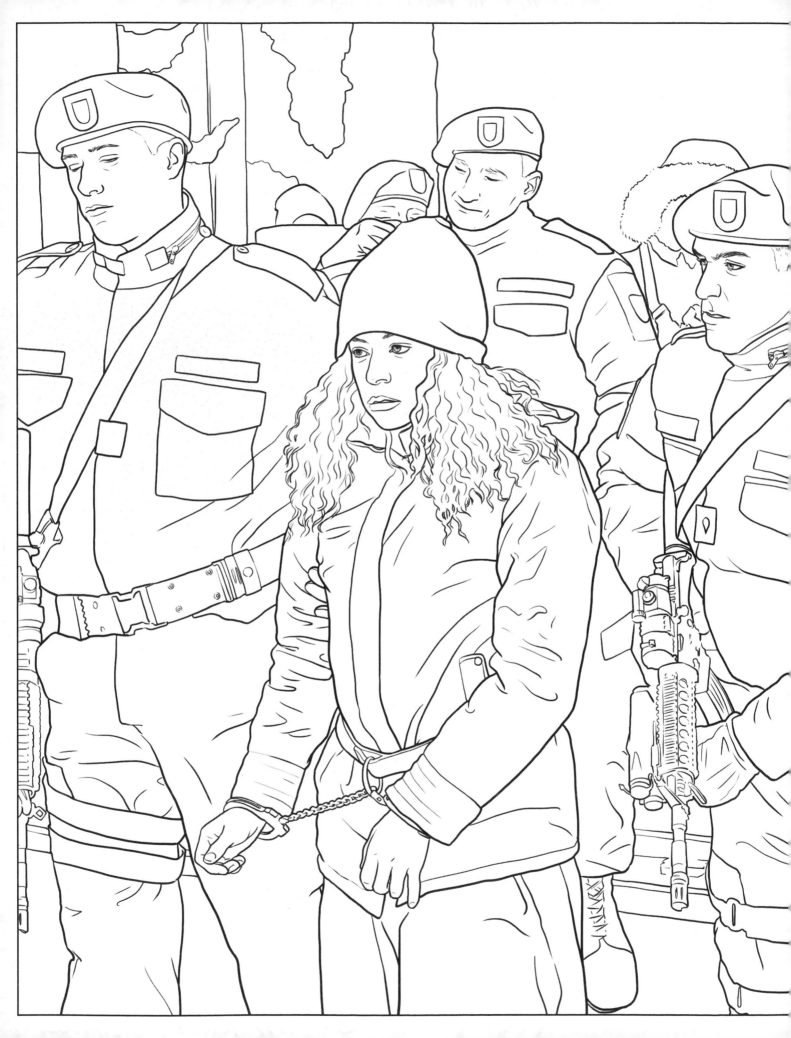

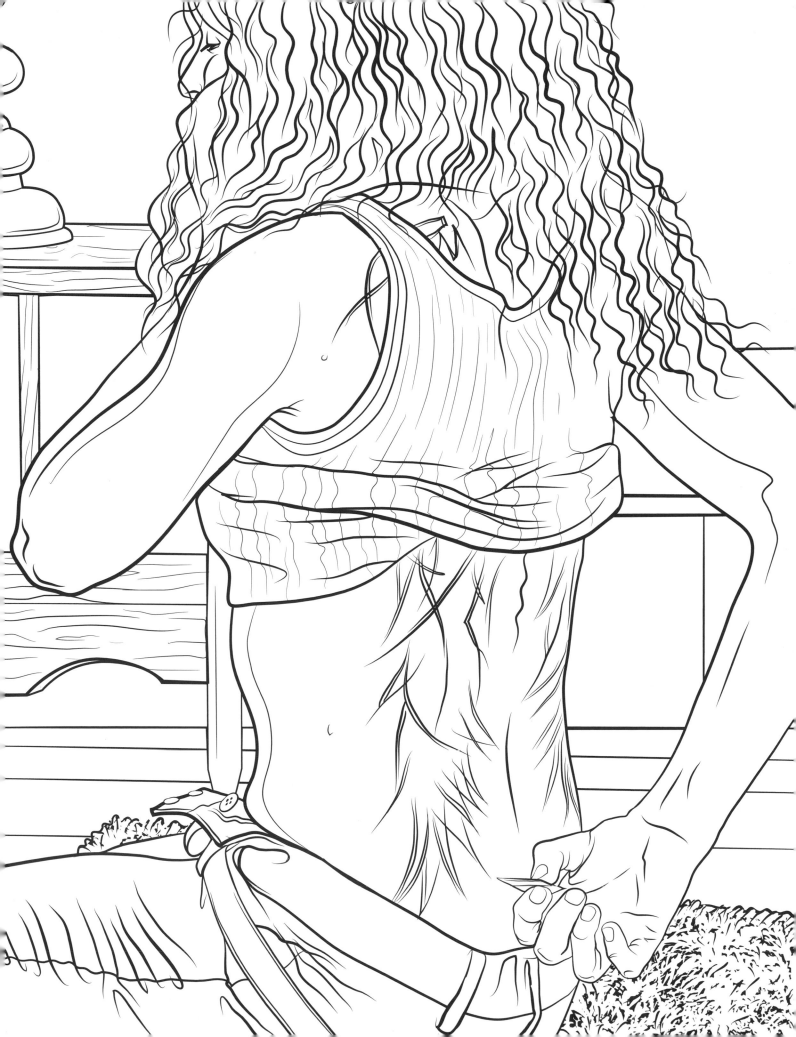

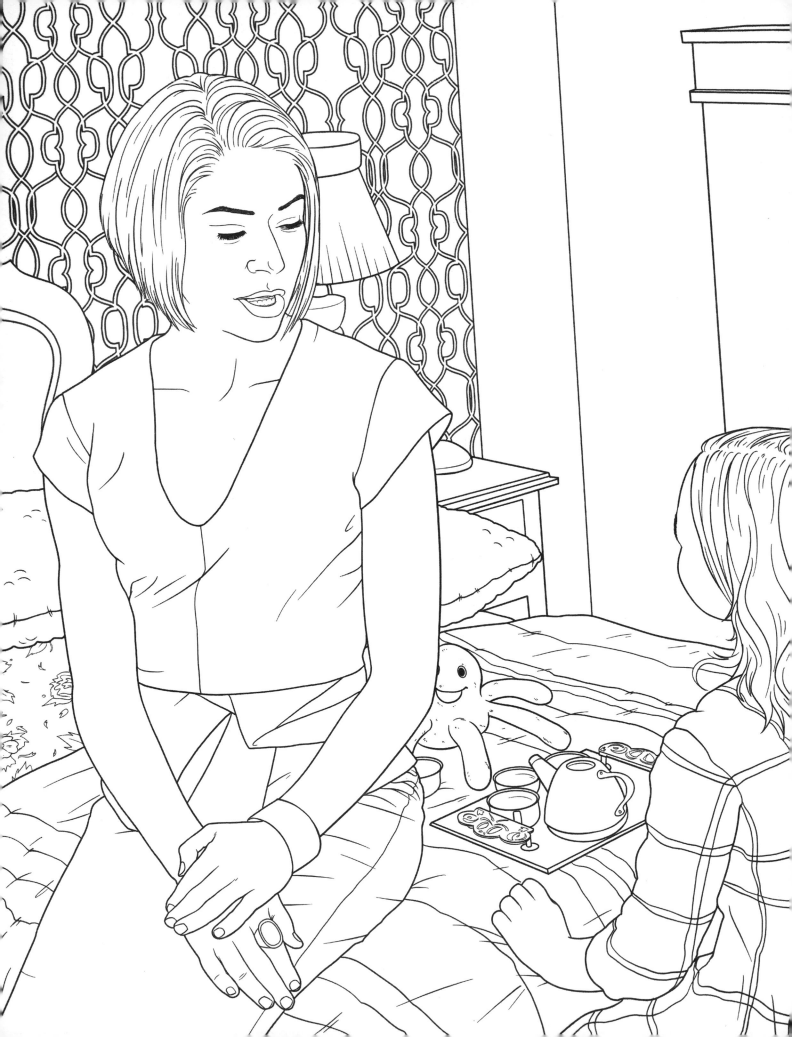

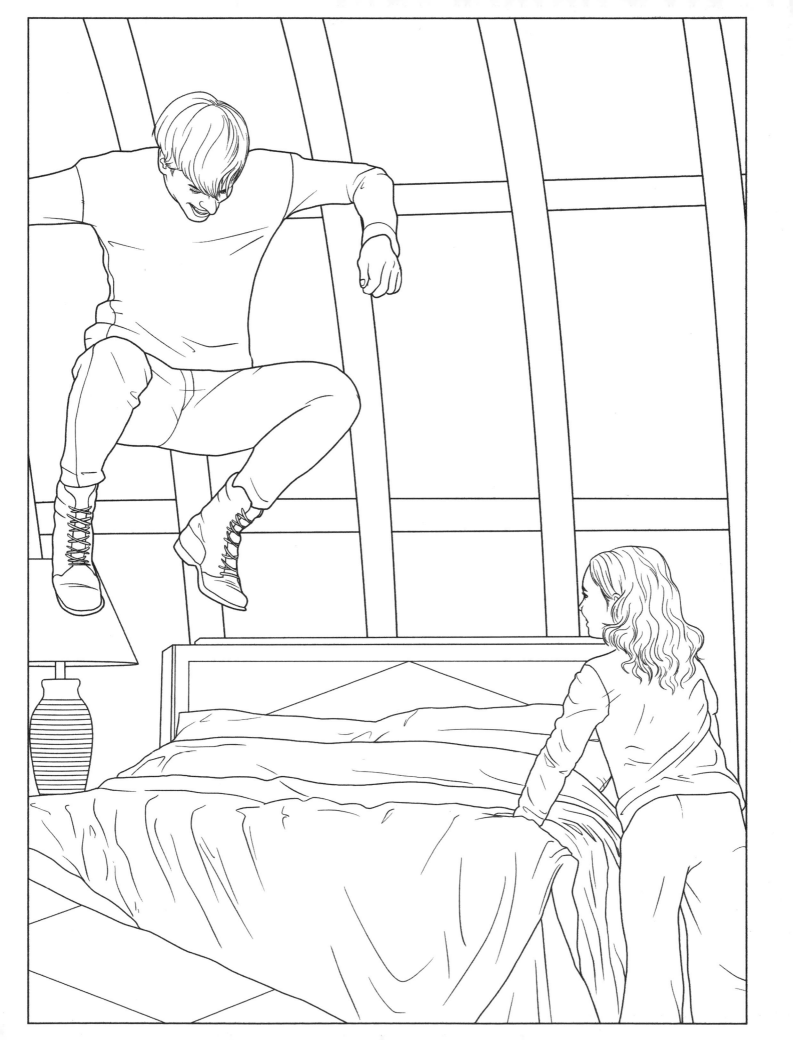

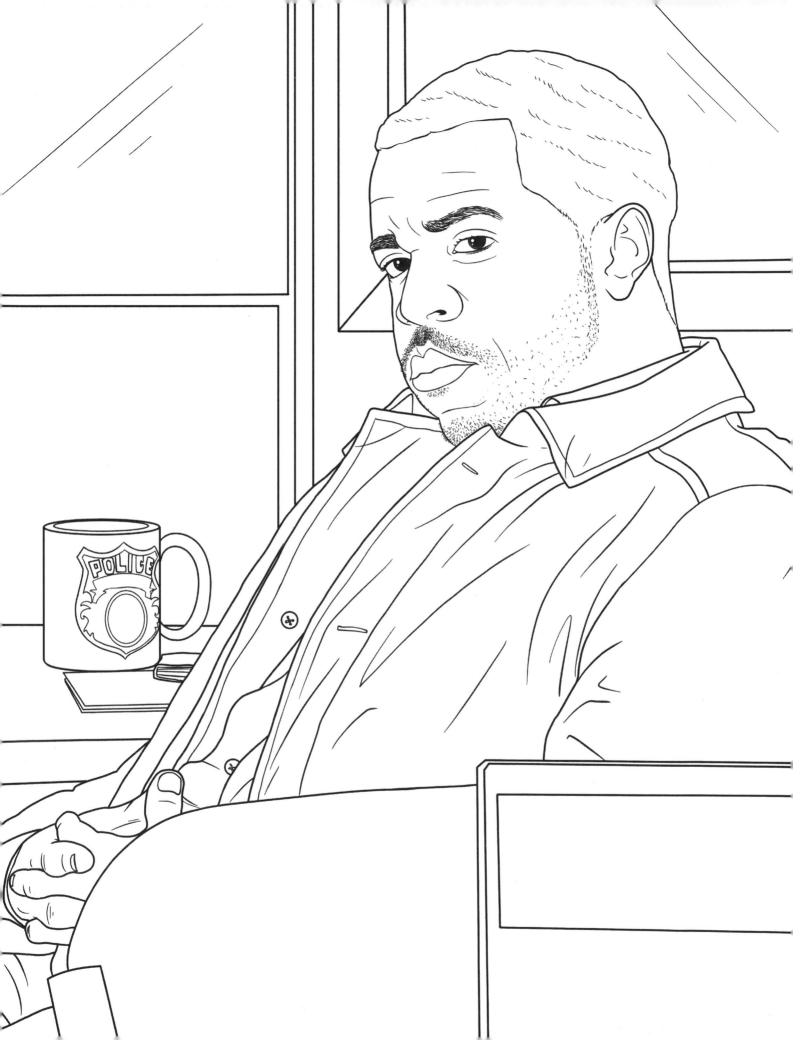

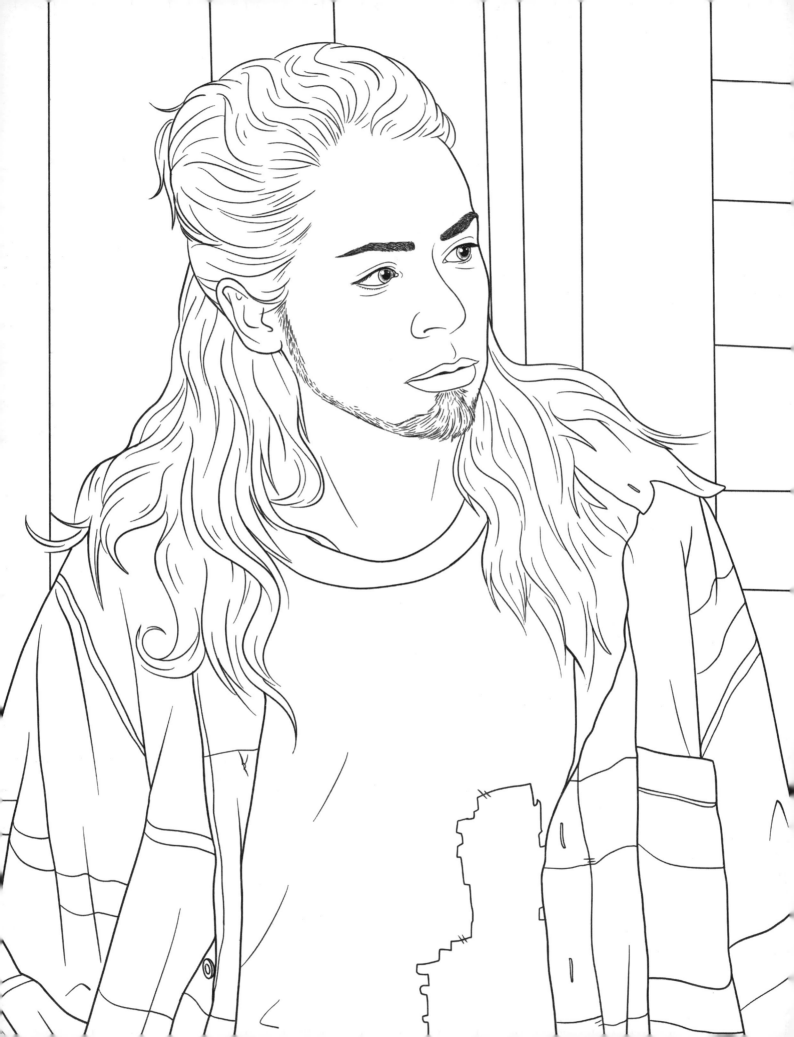

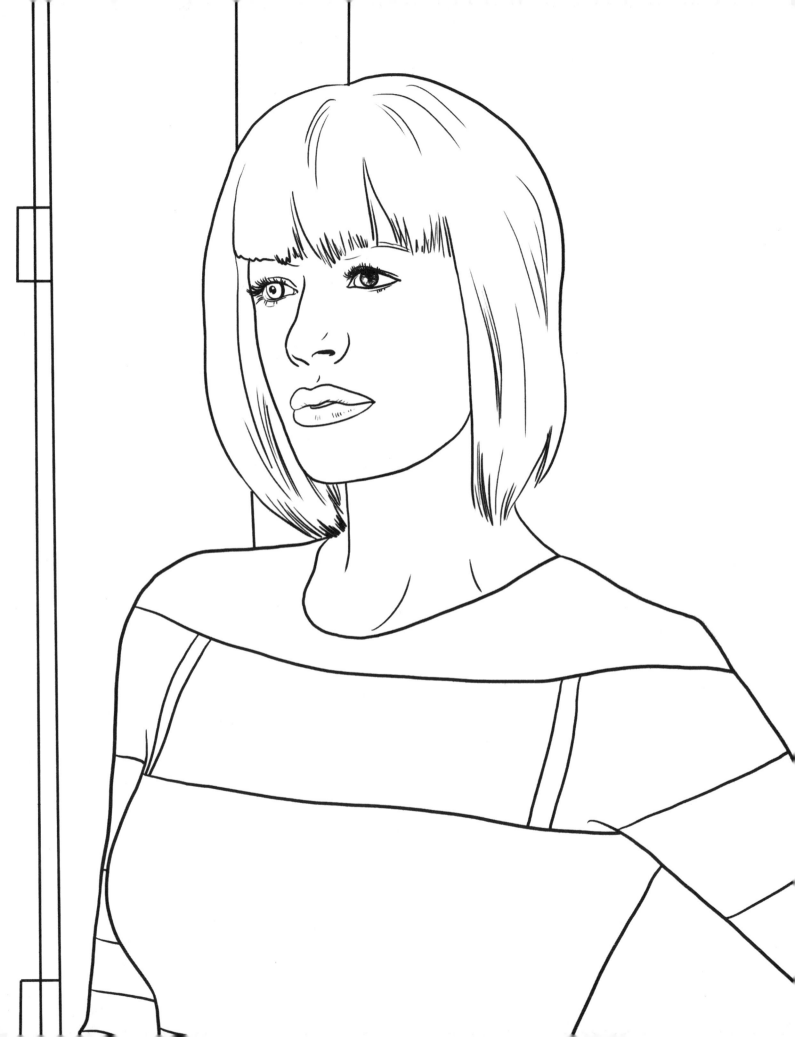

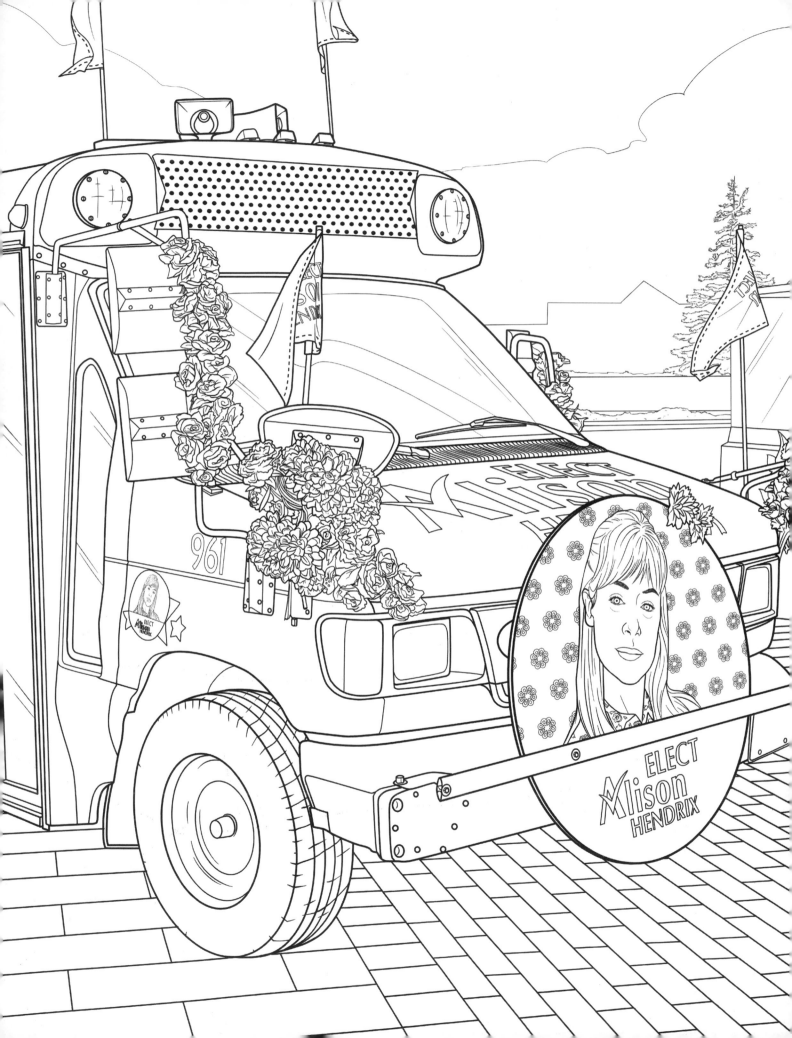

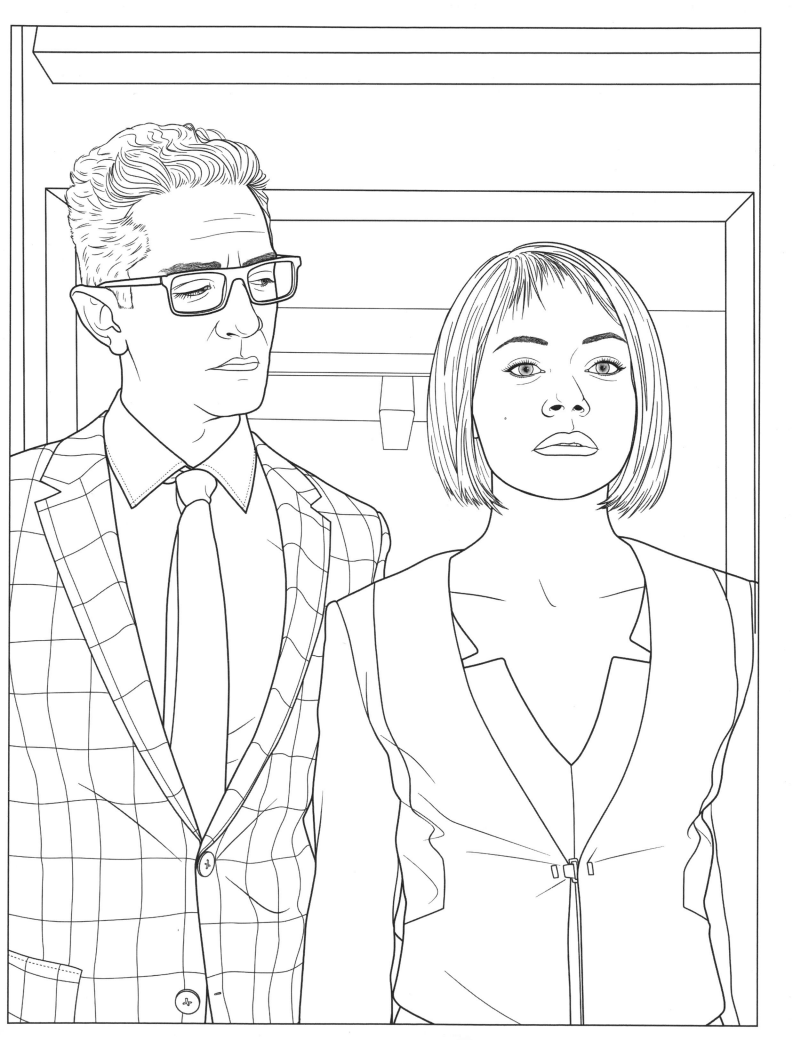

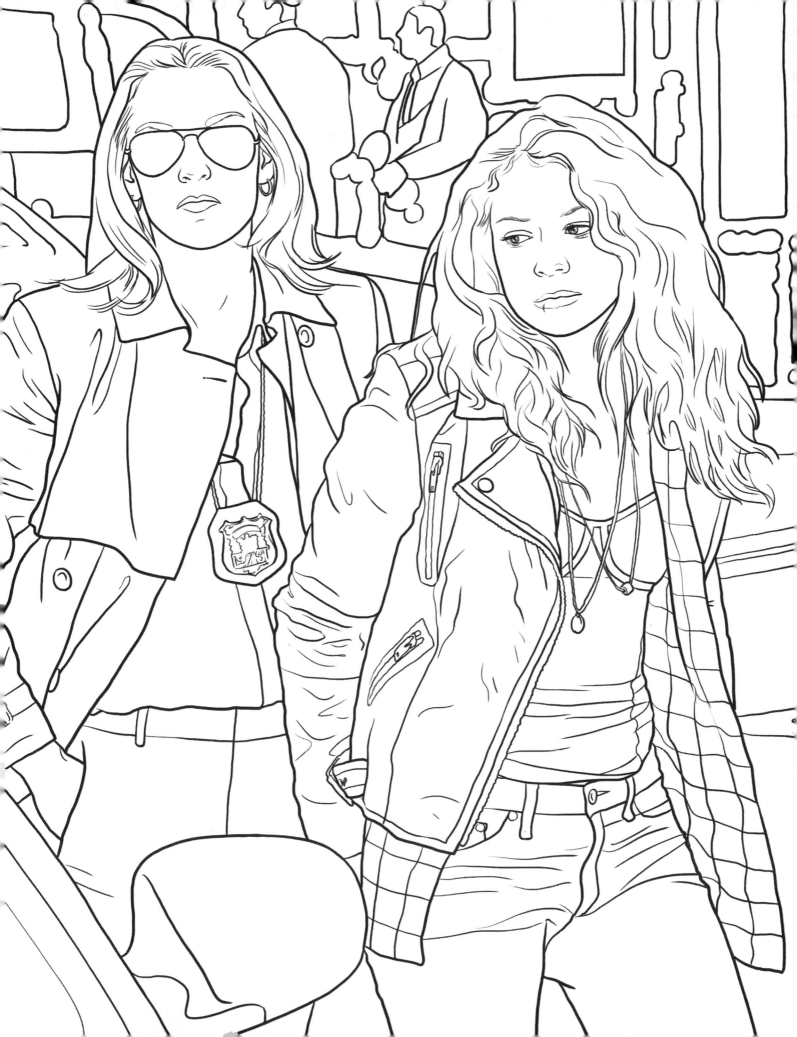

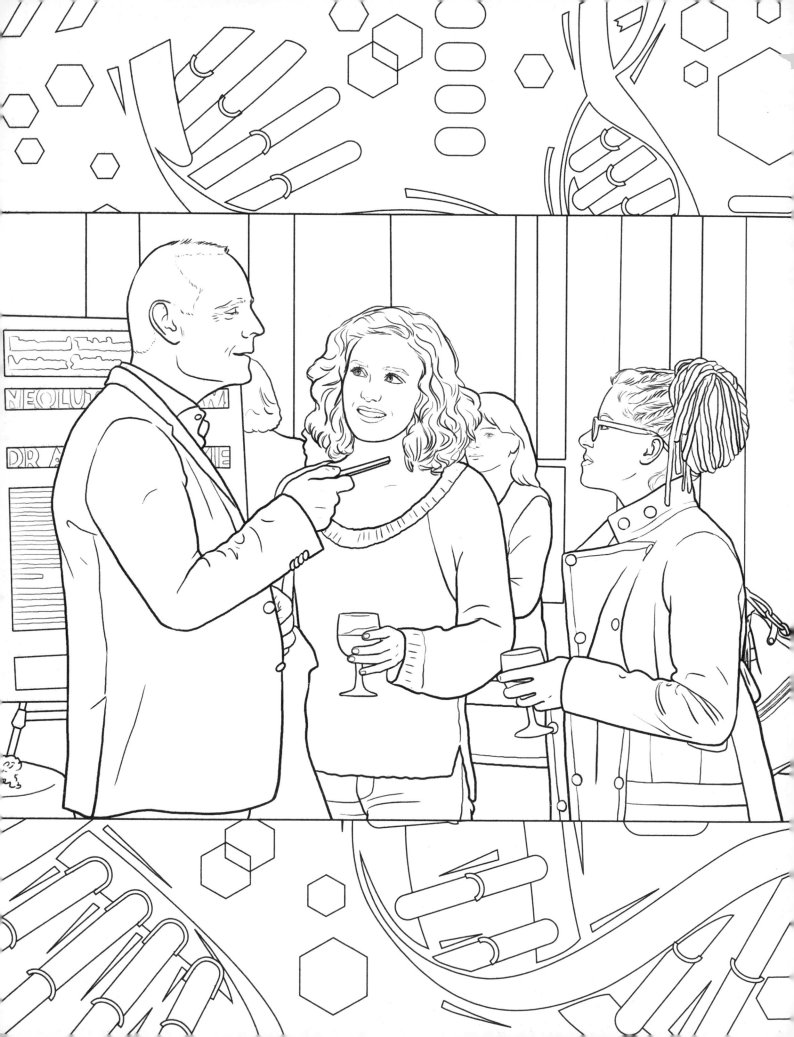

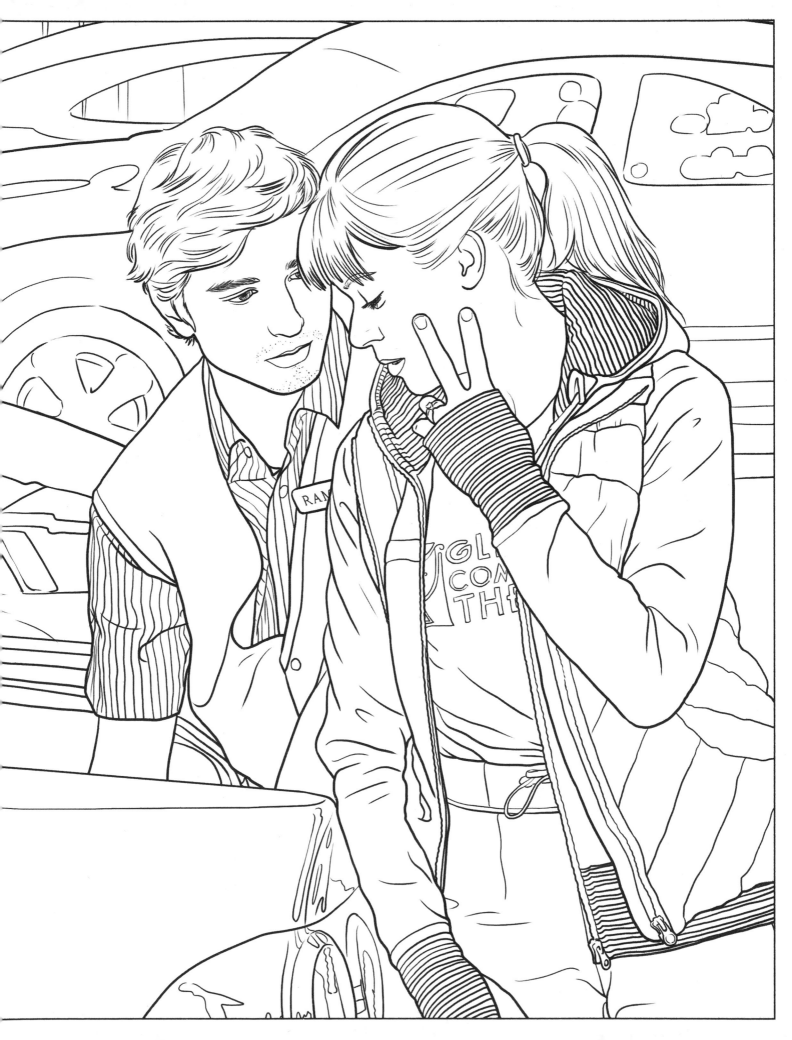

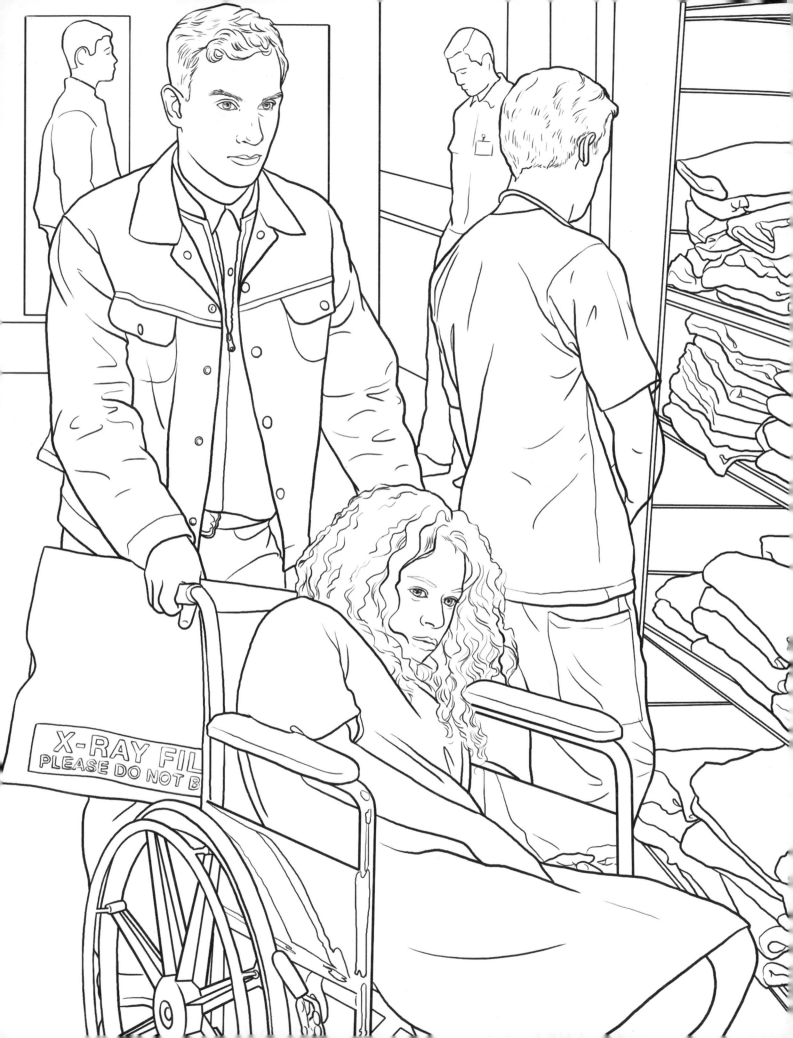

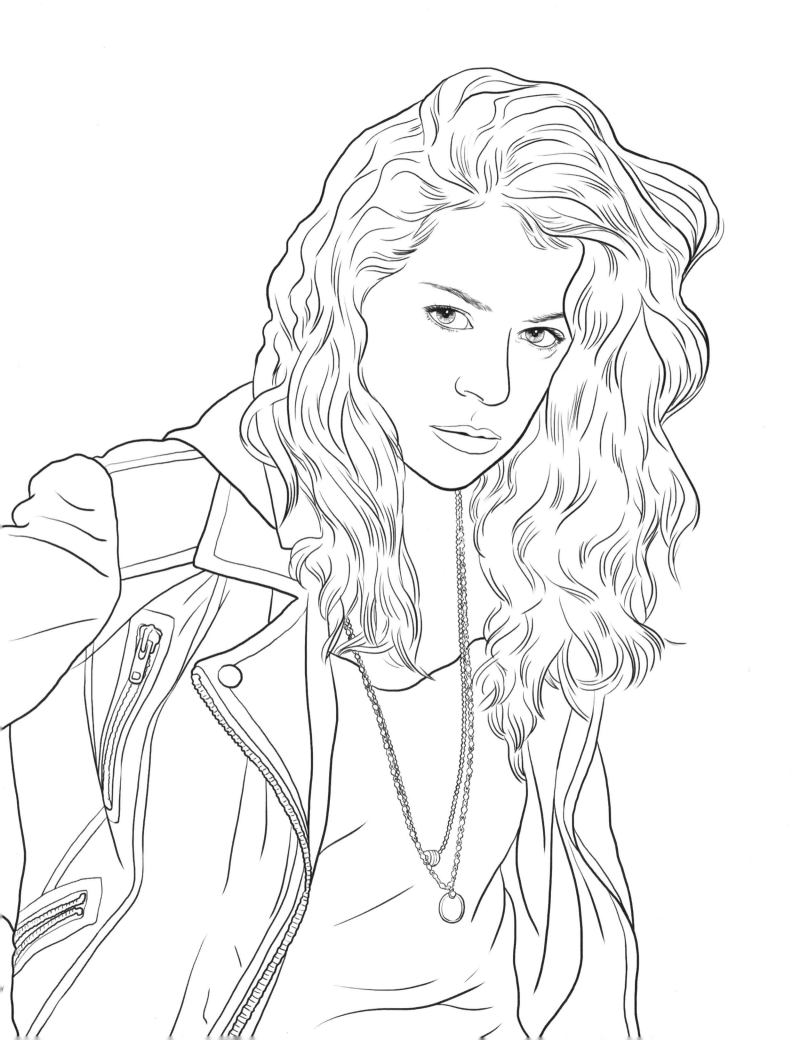

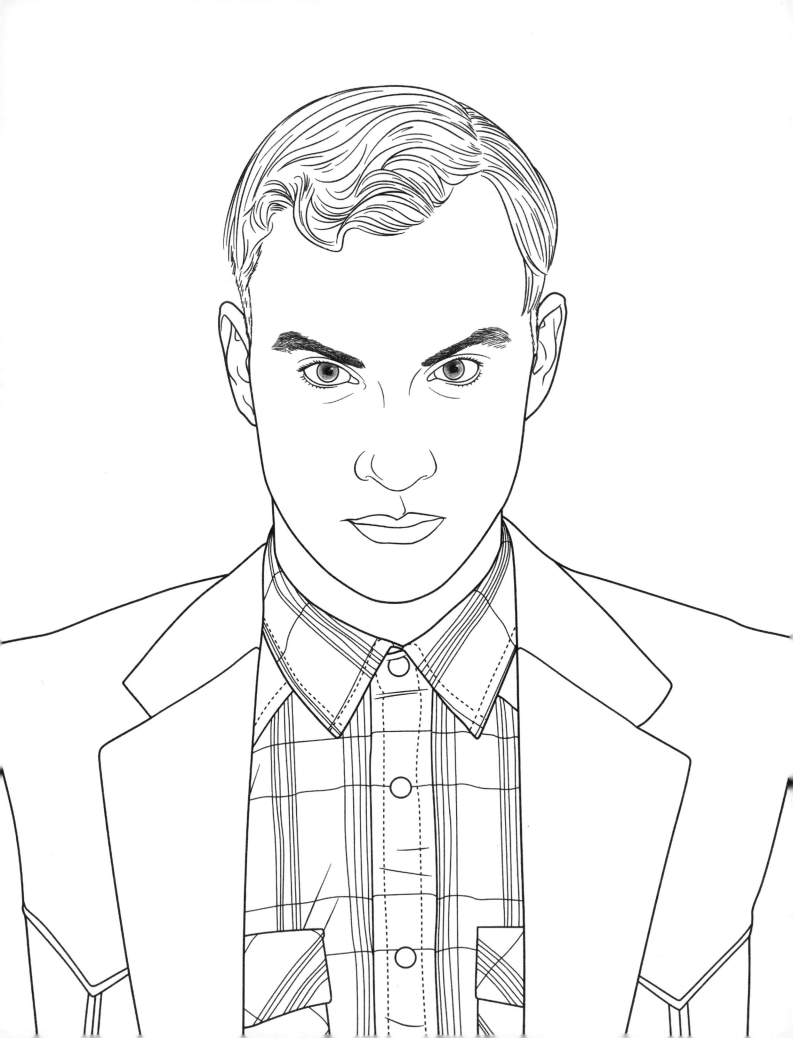

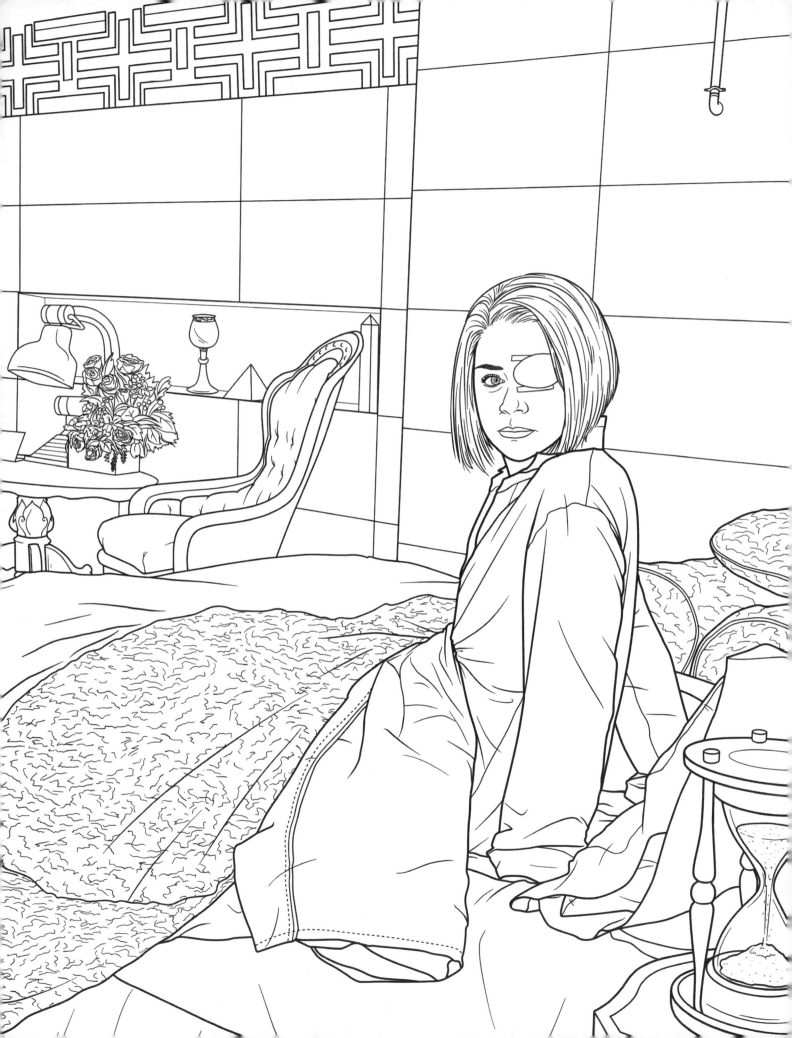

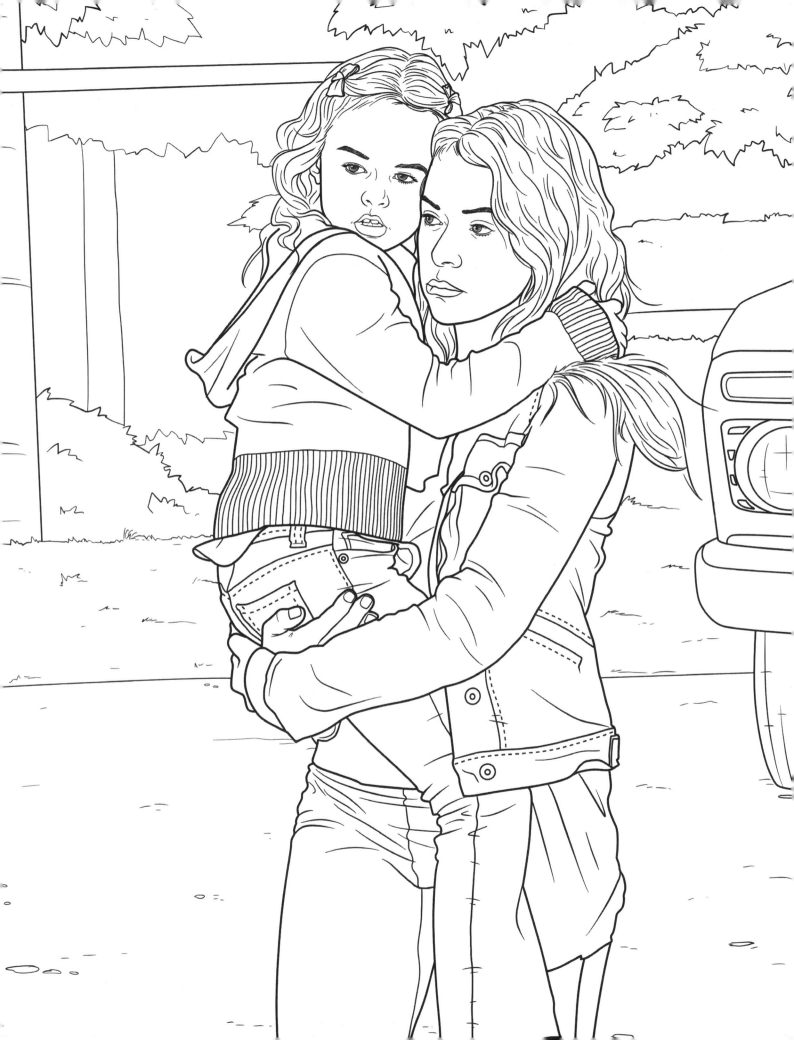

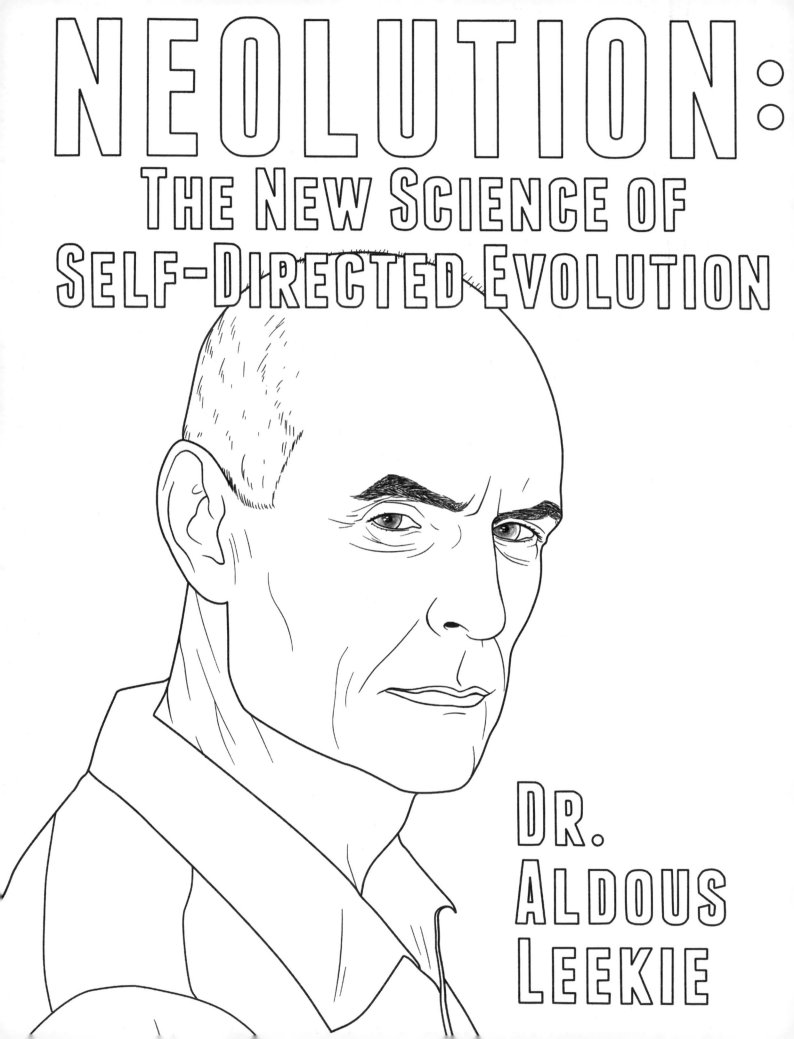

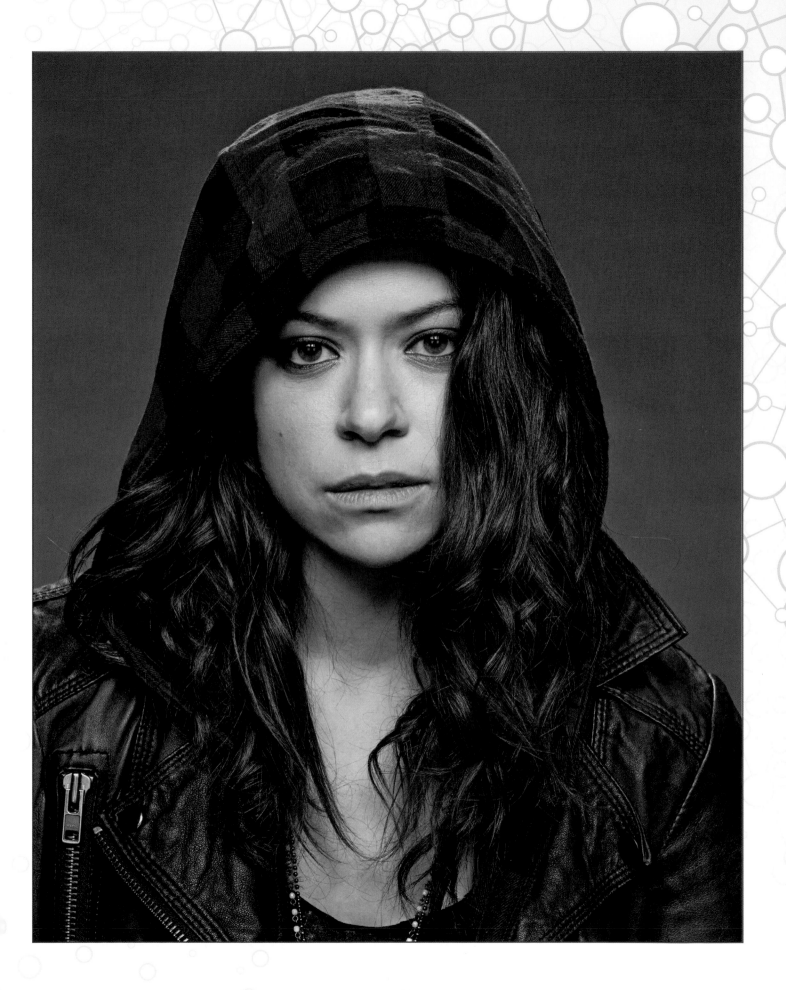

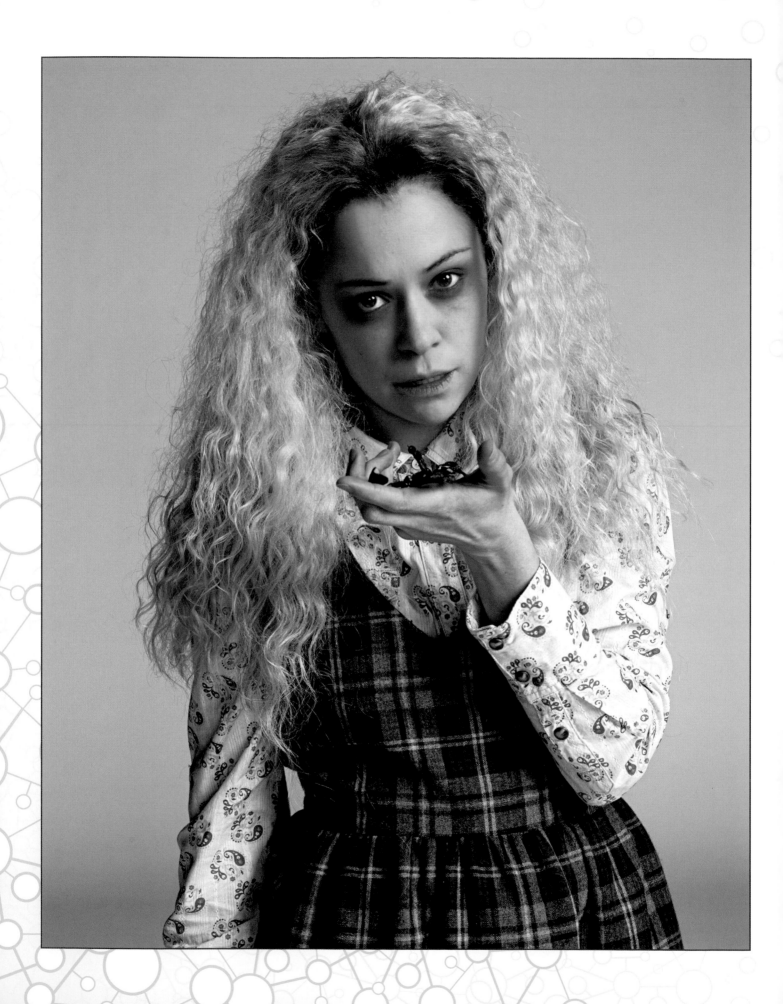

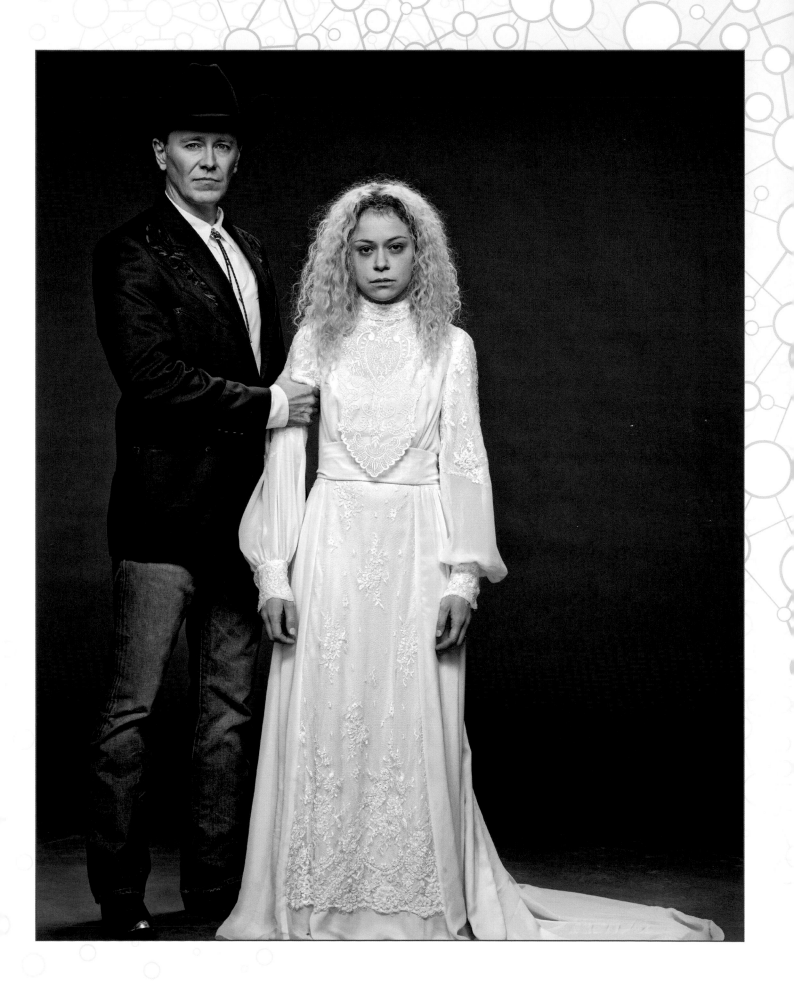

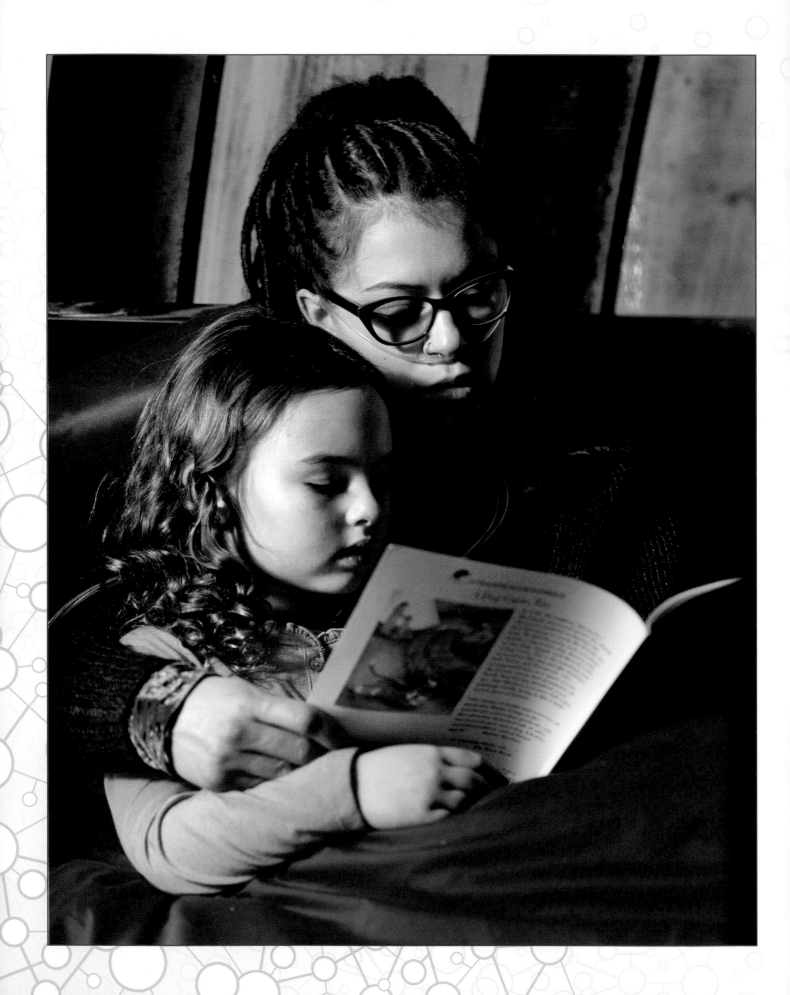

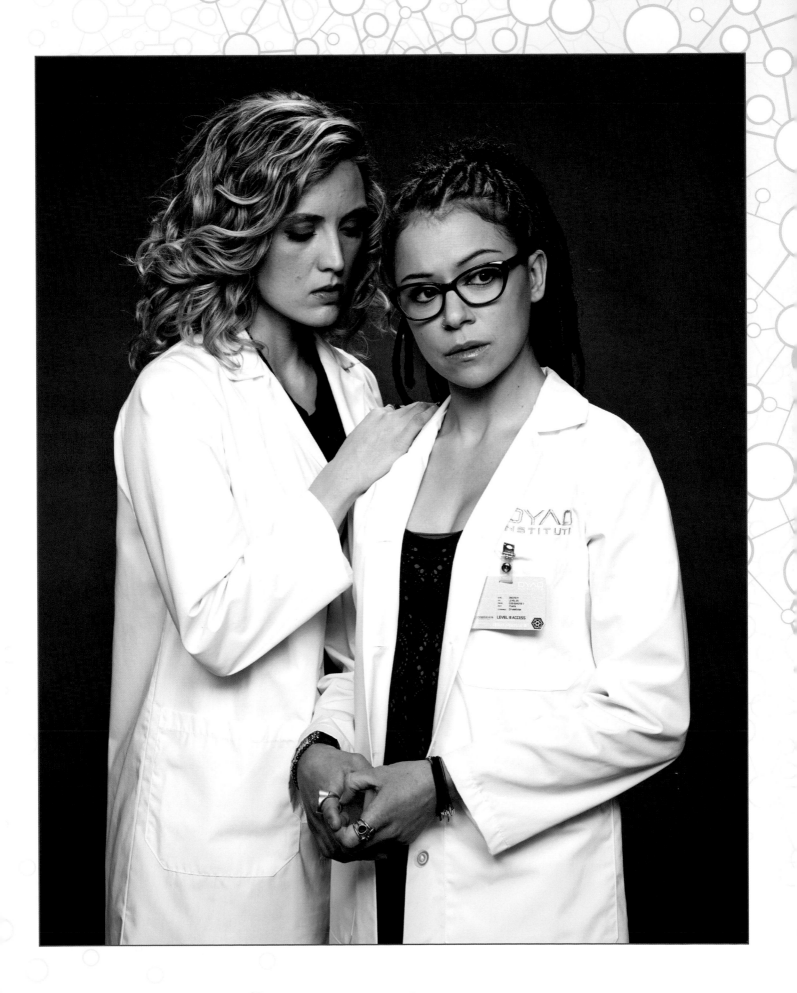

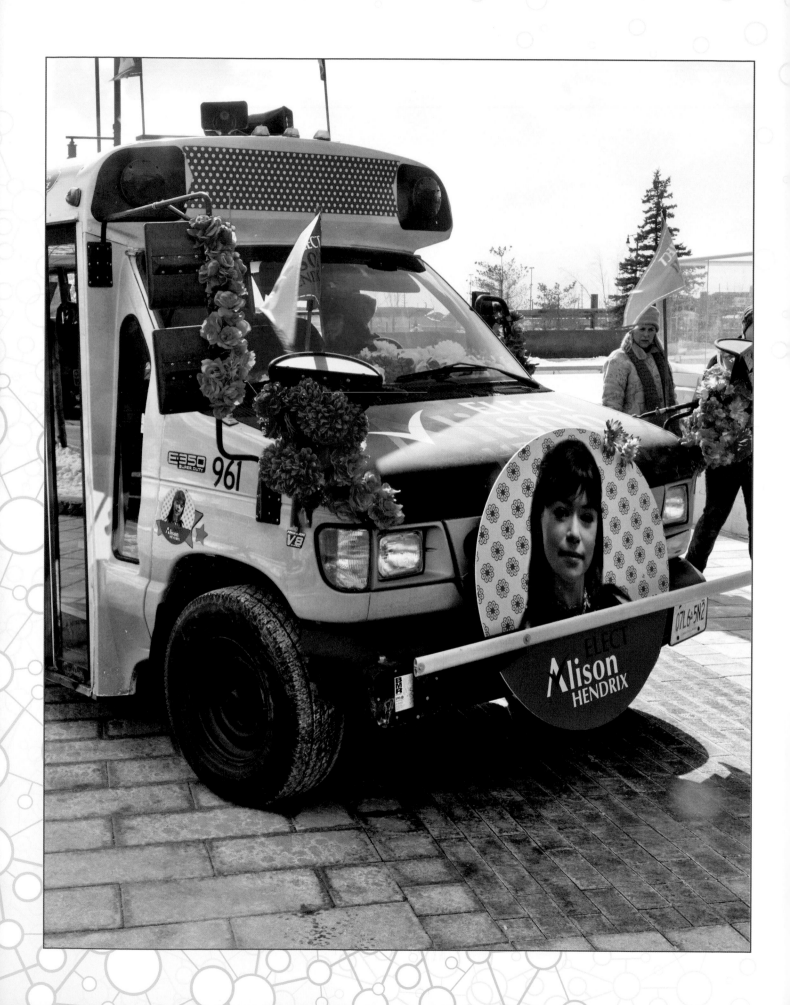

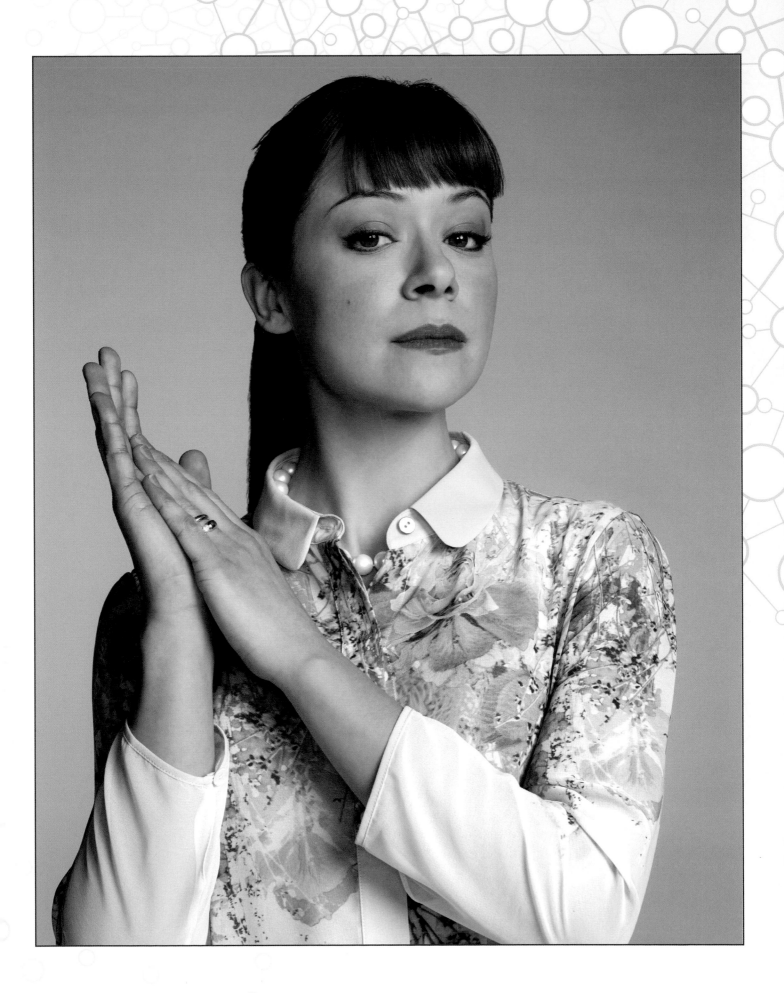

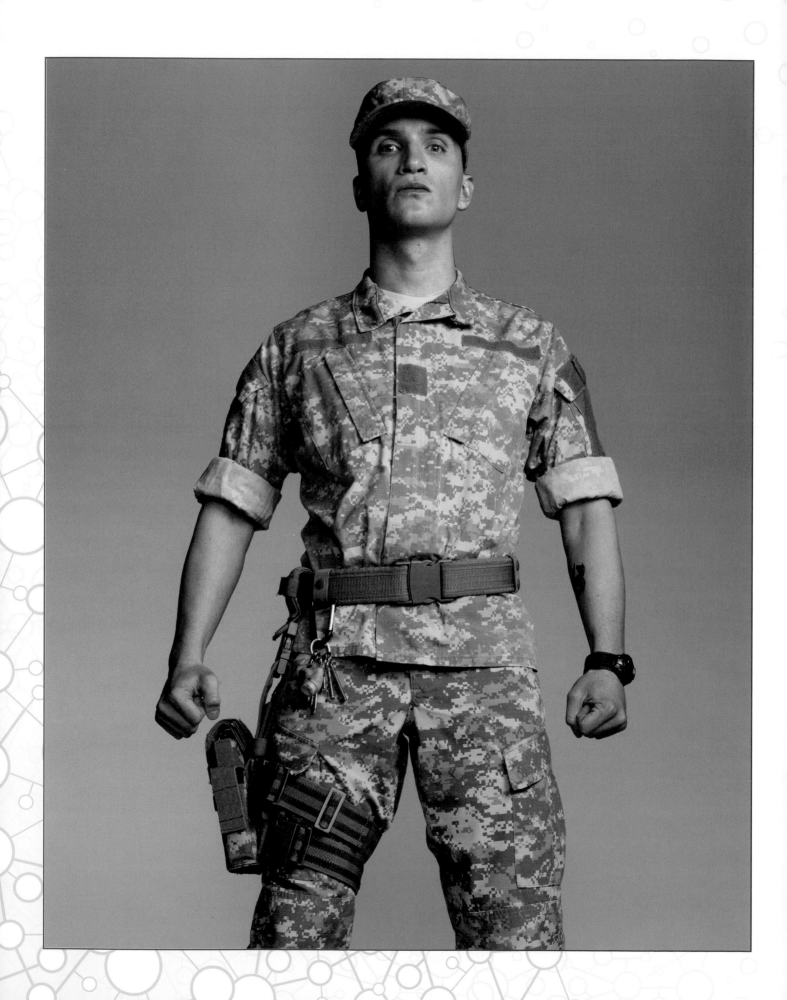

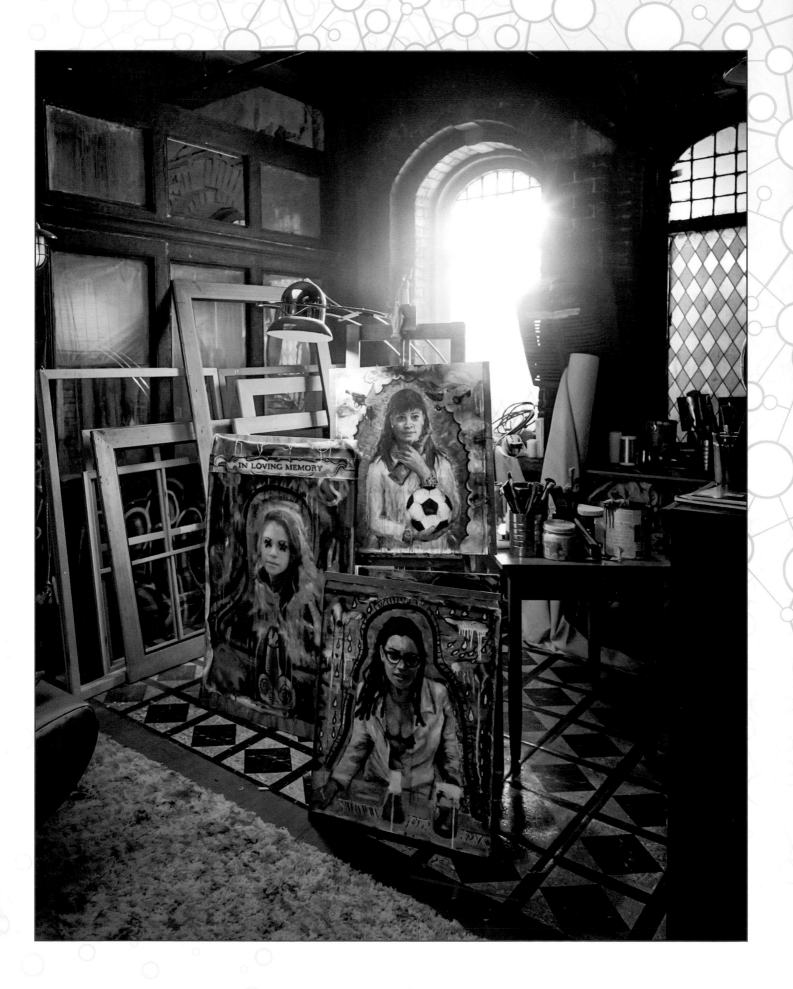

INSIGHT EDITIONS

PO Box 3088
San Rafael, CA 94912
www.insighteditions.com

Find us on Facebook: www.facebook.com/InsightEditions
Follow us on Twitter: @insighteditions

BOAT ROCKER
BRANDS

Published by Insight Editions, San Rafael, California, in 2017. No part of this book
may be reproduced in any form without written permission from the publisher.

Library of Congress Cataloging-in-Publication Data available.

ISBN: 978-1-68383-100-6

Publisher: Raoul Goff
Acquisitions Manager: Robbie Schmidt
Art Director: Chrissy Kwasnik
Designer: Leah Bloise
Project Editor: Kelly Reed
Production Editor: Rachel Anderson
Production Manager: Alix Nicholaeff
Editorial Assistant: Erum Khan

—

Illustrations by Adam Raiti, Robin F. Williams, and Pablo Matamoros

ROOTS of PEACE REPLANTED PAPER

Insight Editions, in association with Roots of Peace, will plant two trees for each tree used in the manufacturing of this
book. Roots of Peace is an internationally renowned humanitarian organization dedicated to eradicating land mines
worldwide and converting war-torn lands into productive farms and wildlife habitats. Roots of Peace will plant two million
fruit and nut trees in Afghanistan and provide farmers there with the skills and support necessary for sustainable land use.

Manufactured in China

10 9 8 7 6 5 4 3 2 1